IMAGES
of America

YREKA

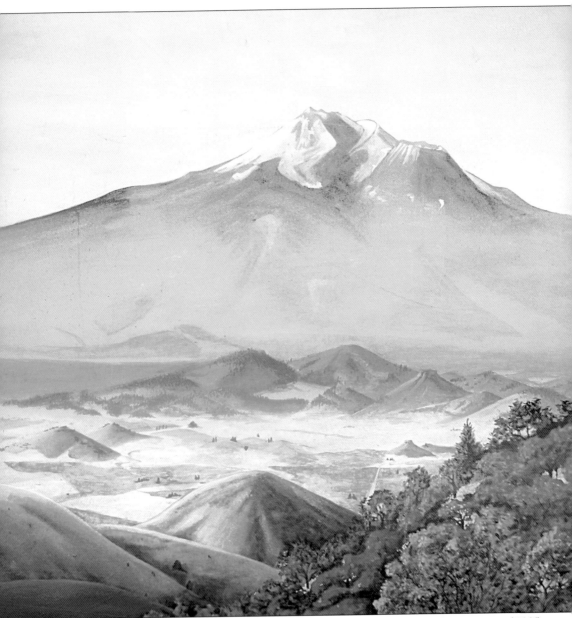

A painting of Mount Shasta as viewed from Paradise Craggy was created in the summer of 1985. This majestic neighbor of Yreka has inspired many artists, writers, historians, and craftsmen both local and worldwide throughout the years of our recorded history. Regional folklore suggests that the name *Yreka* comes from a derivation of a Native American word for "white mountain." (Courtesy Donald East, copyright © 1985.)

ON THE COVER: The California Gold Rush began in 1849, when the first shipload of prospectors arrived in San Francisco. In 1949, Yreka commemorated the century of progress with a three-day celebration. Parade entries, sheriff's posses, and drill teams from surrounding towns and counties were invited. The Klamath Sheriff's Posse shown on the cover created a memorable experience and was awarded first prize for horse groups. (Courtesy Siskiyou County Museum.)

IMAGES
of America

YREKA

Claudia A. East and Karen Cleland,
Donald Y. East and Yale East

ARCADIA
PUBLISHING

Copyright © 2007 by Claudia A. East and Karen Cleland, Donald Y. East and Yale East
ISBN 978-0-7385-4735-0

Published by Arcadia Publishing
Charleston SC, Chicago IL, Portsmouth NH, San Francisco CA

Printed in the United States of America

Library of Congress Catalog Card Number: 2006939083

For all general information contact Arcadia Publishing at:
Telephone 843-853-2070
Fax 843-853-0044
E-mail sales@arcadiapublishing.com
For customer service and orders:
Toll-Free 1-888-313-2665

Visit us on the Internet at www.arcadiapublishing.com

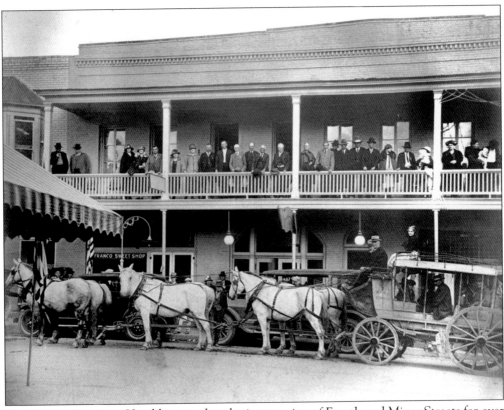

The Franco-American Hotel has stood at the intersection of Fourth and Miner Streets for over 150 years. It began as a small establishment in 1855 and grew with the town. The hotel became a regular stop for stagecoaches arriving in Yreka. It was the crossroads of the community. Today the building looks much the same as it does in this picture, but it is no longer a hotel. (Courtesy Siskiyou County Museum.)

CONTENTS

Acknowledgments 6

Introduction 7

1. Transportation 9

2. Businesses in Town 27

3. Homes, Libraries, Churches, and Cemeteries 53

4. Schools and Government 73

5. Area Industry and Community Events 93

ACKNOWLEDGMENTS

This project could not have been accomplished without the willing and enthusiastic help of so many people. We would like to thank Thelma Visger, Claudia's mother, for her contagious interest in Yreka's history; Jack Burgess, Glen Joesten, and Wes Swift, who provided photographs and information about the fate of the dining car café and about its current restoration; JoAnne A. Smith Mello, who provided photographs of her family candy store and unique street scenes; Harvey Russell for photographs of family and friends; Jim Brooks and Marjorie Brooks, who provided some very old photographs; Charlie Russell, whose photographs make viewers wish they lived in earlier days; V. June Collins and her cohorts, who were able to name the Trail Riders in Russell's photograph; Jack Morgan, who provided background on the Yreka Indians baseball team; Rebecca Desmond, chief executive officer of the Siskiyou Golden Fair, who provided many photographs of the fair; Neves Machado, who brought county fair experience to life; Mary O'Kelley of Yreka Western Railroad, who provided an extraordinary photograph of the Blue Goose Excursion Train; Wilbur Van Over, who provided a photograph of the Masonic Lodge; Ruth Seifert, who explained the philosophy of the Odd Fellows and Rebekahs; David Favero; library director Dennis Freeman, Ellie Mauro, and Marcia Eblen for images of the College of the Siskiyous and retired instructor Bruce Friend for historical information about the College of the Siskiyous; Rod Dowse, publisher of the *Siskiyou Daily News*, for letting us rummage through boxes of old photographs; John Skarstad, archivist of University of California at Davis's Special Collections, for the use of the Eastman photographs; and county librarian Elizabeth Emry and the staff at the Siskiyou County Library, Yreka Branch, for photographs and research materials.

A special thank-you must go to museum director Mike Hendryx and museum technician Dick Terwilliger of the Siskiyou County Museum. The museum collection is vast, well organized, and a pleasure to use.

Another special thank-you is offered to the Siskiyou County Historical Society for the effort taken to document Siskiyou County history in the well-researched articles and remembrances written by members in its publication, the *Siskiyou Pioneer*.

A final thank-you must be given to Devon Weston, our editor at Arcadia Publishing. Devon's patience, guidance, and encouragements have made this an enjoyable experience indeed.

INTRODUCTION

Yreka and its 150 years of marvelous history shine like gold nuggets in a mountain stream waiting to be discovered in one of California's most interesting and beautiful areas. Hidden from view, this original Gold Rush town of Yreka is just north of the majestic Mount Shasta and south of the Oregon border.

The discovery of gold brought an influx of people arriving hurriedly to Yreka, and commerce followed equally as rapidly to provide food, whisky, supplies, and shelter to the miners. It was 1852, and Yreka scrambled into being upon the Flats. A permanent town site developed a short distance away along Yreka Creek. The California State Legislature created the county of Siskiyou a few months later, and a county seat was to be named. A neighboring town, Deadwood, once an established community, vied for the title of county seat. Elections were held, and Yreka won by a mere handful of votes. (Some say a wagonload of whisky delivered to the swing-vote town of Etna on the eve of the election caused a low voter turnout.) Today nothing is left of Deadwood except a small marker that indicates where the town once stood. On April 21, 1857, Yreka incorporated, and "The Golden City" evolved from a truly wild-west town to a contemporary, full-service community.

Mining continued in the Yreka area following gold discovery and, on a smaller scale, carries on to this day. Being a mining town, the area was originally filled with adventurous men and a few women. History has often shown it is the younger generation that takes major interest in new technologies. The newest mining technologies were sought out and employed, making at least a few rich, and many other new and wonderful things were to be had. Yreka was one of the first towns between San Francisco and Portland to have telegraph service, was very early in the adaptation of electricity and water systems, and had its first telephone system in 1897. In addition to mining, the rich natural resources of the area have a wide range of financial interests that fuel the economy of Yreka and its citizenry.

Farming and ranching were also vital early industries, and even as late as 1915, public lands were available to the homesteader. Raising crops and herding livestock are still prominent and thriving industries today. Forestry was a large boon to regional and distant building. Mills once specialized in fine-grained lumber, sashes, doors, boxes, and shingles, and as an industry, millers utilized the nearby train routes extensively.

Transportation has been essential to the health and growth of Yreka since its inception. From moving goods and supplies to the miners and transporting agricultural and timber products to metropolitan areas to being able to communicate with other governmental agencies and transport people quickly, many varied forms of transportation have helped the growth and prosperity of the town. In particular, the main route of the once-great Pacific Highway, a major artery for automobile travel from San Francisco or Sacramento to points north, has provided economic health to Yreka; the highway was renamed and rebuilt in the 1930s as Highway 99, with portions now serving Interstate 5.

Yreka serves as a city and government center. It was an instrumental communications center during the last armed resistance of Native Americans in California, the Modoc War, in 1872–1873. In 1875, William Irwin, hailing from Yreka, served as governor of California. One of the last stage robberies was in this area, right up the road at Robbers' Rock, in the late part of the 1800s. In 1885, a vigilante group took matters into its own hands and hanged four prisoners, all accused of murder, right outside the courthouse. Local legend says the tree on which they were hanged died shortly afterwards. No other murders occurred in the county for nearly 20 years following that event. In 1906, Yreka responded to the needs of San Franciscans following the great earthquake with the donation of more money and goods per capita than any other city. During the 1930s, the last lynching in California took place only a short distance away. In 1941, Yreka was named the capital of the newly formed State of Jefferson. Although a new geographic state did not emerge from that political movement, it is said that a new state of mind did materialize. In the 1970s, Yreka became honored with a designation on the National Register of Historic Places and today offers a walking tour of historic homes and the historic business district.

Yreka has the honor of sitting in the shadow of the majestic Mount Shasta, one of the most photographed and beautiful mountains in the world. Invitation awaits the reader to turn the pages and discover the nuggets of history that lie ahead.

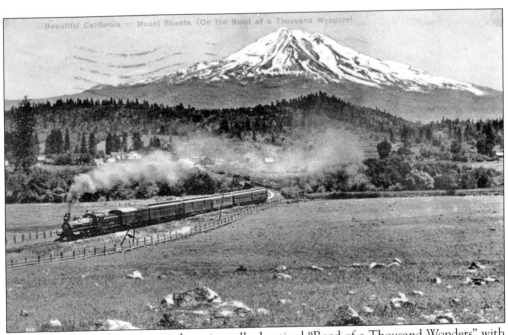

The Southern Pacific train travels on its well-advertised "Road of a Thousand Wonders" with Mount Shasta in the background. The route did not connect directly to Yreka; patrons had to change in neighboring Montague and ride the Yreka Railroad spur into town or use alternative transportation such as the local stage or courtesy hacks from the hotels. The train route became available here in the late 1880s. (Courtesy Claudia East Collection.)

One

TRANSPORTATION

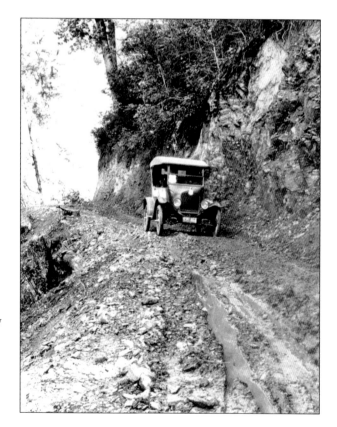

A U.S. government vehicle travels a typical mountain road in 1923. Road accessibility and condition has been a political issue in Northern California since statehood was granted. In 1896, the California Bureau of Highways recommended a system of highways connecting all county seats that would create or use existing roads of approximately 4,500 miles. Many roads in the Yreka vicinity were not fully paved until the 1930s. (Courtesy Siskiyou County Museum.)

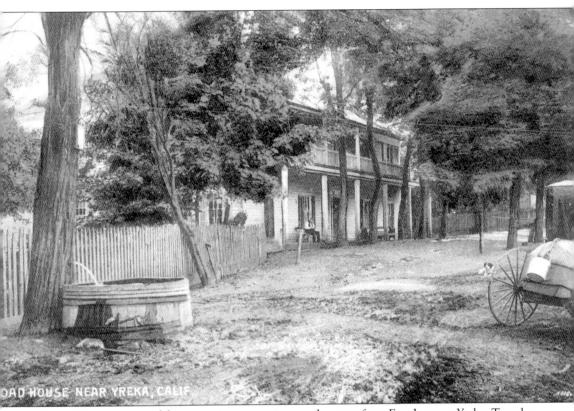

OAD HOUSE NEAR YREKA, CALIF

Forest House was one of the major stopping points on the route from Fort Jones to Yreka. Travelers could water and rest their horses, partake from the spirits offered in the bar, or engage a room for the evening to begin their journey fresh the following day. The Forest House and ranch was also noted as a stopover for livestock being driven for market from the Scott Valley to Yreka. The first recorded image of the house is an early tintype from about 1855; the above image dates from around 1905. Today one can still observe the water flowing from the pipe into a wooden trough. The Forest House, privately owned and in the Burton family since 1907, no longer operates as a roadhouse but appears much the same as it did in this picture. (Courtesy Claudia East Collection.)

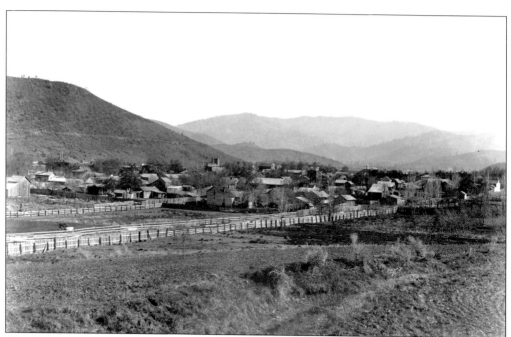

This beautiful early photograph is one of the few taken from a point north of Yreka. St. Joseph's Catholic Church, St. Mark's Episcopal Church, the white dome of the Union Church, and the East Side Ditch on Butcher Hill can be easily seen. The East Side Ditch was built in 1879, and the Union Church was torn down in 1898. (Courtesy Siskiyou County Museum.)

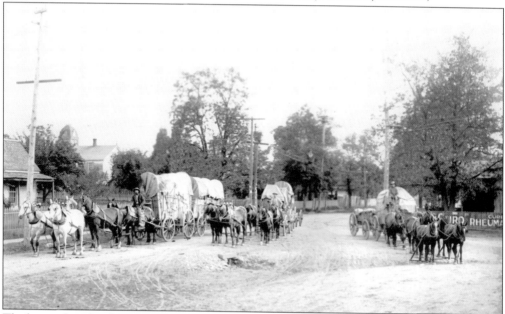

The heavy-duty freight wagons seen above were loaded and ready to depart when this photograph was taken around 1895. These wagons were large enough for loads up to eight tons and were drawn by four to eight mules. The smaller wheels in front reduced the turning radius, and large wheels in the rear softened the ride. This group stands on a road near Courthouse Square. (Courtesy Siskiyou County Museum.)

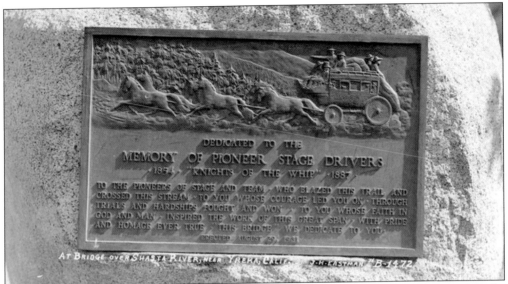

Pack trains, freight wagons, and stagecoaches were lifelines for Gold Rush towns, and Yreka was no exception. Steep terrain between Yreka and the Sacramento Valley to the south and Ashland to the north made travel difficult and roads hard to build. Gold was routinely shipped on stagecoaches passing through remote locations, and many were robbed. The men who drove the stagecoaches were a special breed. They were tough, dedicated, and determined to provide reliable transportation. The plaque above honors those men who played such an important roll. The Wells Fargo drivers, shown below with whips, rifles, and a strongbox, look ready to take on any threat. (Above courtesy University of California–Davis [UC Davis], Special Collections, below courtesy Siskiyou County Museum.)

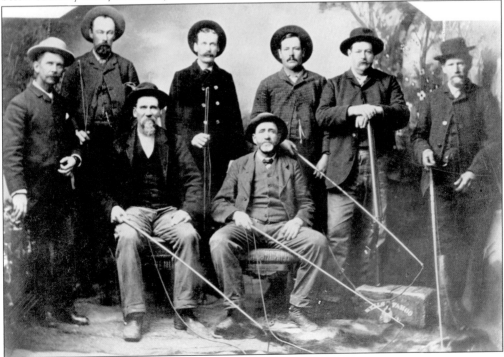

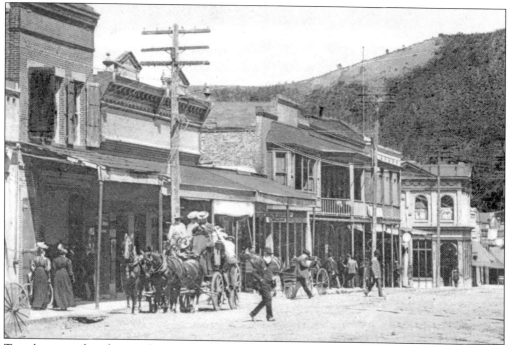

Travelers, merchandise, and supplies moving along the north-south interior route between San Francisco and Portland had to pass through Yreka. This photograph, taken in the early 1890s, shows the busy downtown district. The odd juxtaposition of electric lines and horse-drawn vehicles shows a town moving into a new age. Electric lights and power were provided to Yreka in 1891 by James Quinn, owner of Yreka's first electric plant. (Courtesy Siskiyou County Museum.)

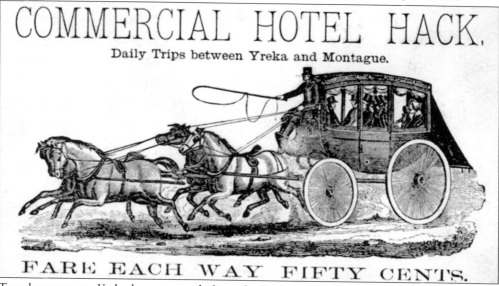

Travelers came to Yreka by stagecoach from the Scott Valley, Oregon; Redding; coastal; and Klamath River communities. The Commercial Hotel Hack met the incoming stages to carry the travelers and their luggage to the Commercial Hotel in Montague. In 1888, the Yreka Western Railroad opened its rail line between Yreka and Montague and charged 50¢ for a one-way trip and 75¢ for a round trip. (Courtesy Siskiyou County Museum.)

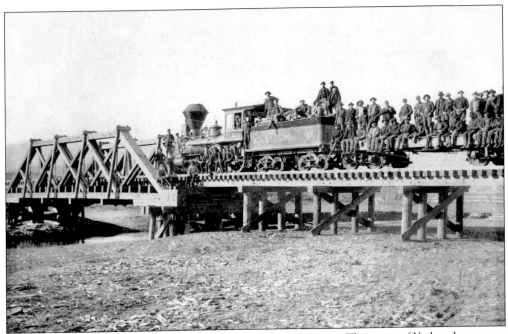

In 1887, the California-Oregon Railroad line reached Montague. The town of Yreka, the county seat of Siskiyou County and a center for commerce, lay 13 miles west of the new railroad line. Citizens, town officers, and businessmen all believed that Yreka's future depended upon a new line connecting Yreka to the California-Oregon Railroad line. On May 28, 1888, Yreka Railroad was incorporated with a capital stock of $100,000. Within days, the contract for construction of the railroad was let; the engine, cars, and track were ordered from New York; and a contract was let for railroad ties. By September, many workers and teams were at work grading and leveling the roadbed. (Above courtesy Siskiyou County Museum; below courtesy Marjorie Brooks Collection.)

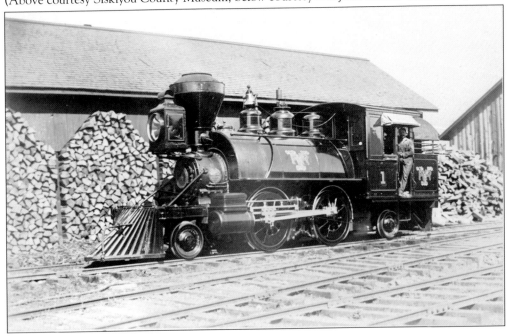

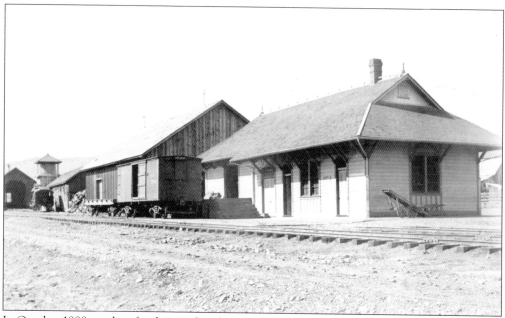

In October 1888, grading for the new line between Montague and the Shasta River was complete, and bridges over the Shasta River and Yreka Creek were under construction. The rails arrived in Montague in early November, and workers immediately began laying track. All the track was laid, the bridges built, and the depot and the roundhouse finished when Engine No. 1, "Old Betsy," arrived in Montague on December 19, 1888. After Yreka Railroad officially opened for business on January 6, 1889, the trip to Montague took only 15 minutes by train, whole railroad cars full of merchandise began arriving in Yreka, and Yreka moved into the steam age. (Above courtesy Marjorie Brooks Collection; below courtesy Siskiyou County Museum.)

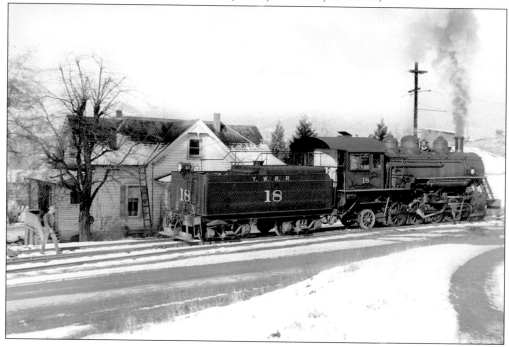

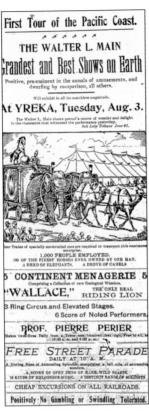

The Walter L. Main Circus came to Yreka on August 3, 1897. A paragraph in the *Yreka Journal* published the morning of August 3 warned readers: "This show causes another legal holiday in Journal office, same as 4th of July and Xmas as the force employed want to see the horse riders, clowns, acrobats and the wild animals, especially the voracious amphibious 'Bovalapus' which, according to the show bills, swallows natives of Africa without even masticating them." Later editions stated that the circus held only one show that day and that 3,000 people attended and went home fully satisfied. At 7:00 p.m. that evening, the circus train pulled out of the Yreka depot. As the train crossed Main Street, a rail snapped. One car was thrown completely from the track and another derailed. The calliope was demolished and a large bandwagon badly damaged. The circus crew worked until 4:00 a.m. the next morning to clear the track. (Above courtesy Karen Cleland Collection; below courtesy Siskiyou County Museum.)

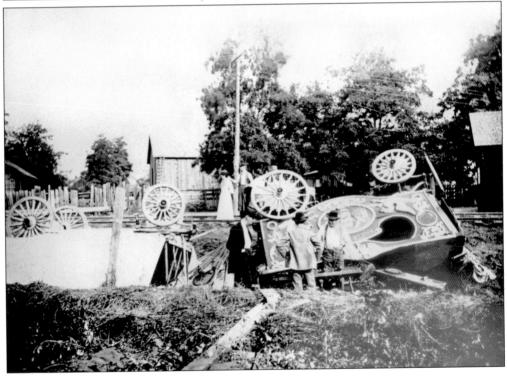

This photograph of the Yreka, Fort Jones, and Etna Stage shows one of William Stone's stages ready to leave the train station in Yreka for the trip to the Scott Valley. People using the rich timber, agricultural, and mining lands of Scott Valley southwest of Yreka wanted the Yreka Railroad line extended to service the valley, and in 1904, the Yreka and Scott Valley Railroad Company was formed. After the survey of the 42-mile route, it was estimated that the cost for construction of the new line would be $1 million, and the plan was dropped. Stagecoaches and freight wagons would continue to serve the valley until they were replaced by automobiles, trucks, and buses. (Above courtesy Karen Cleland Collection; below courtesy Siskiyou County Museum.)

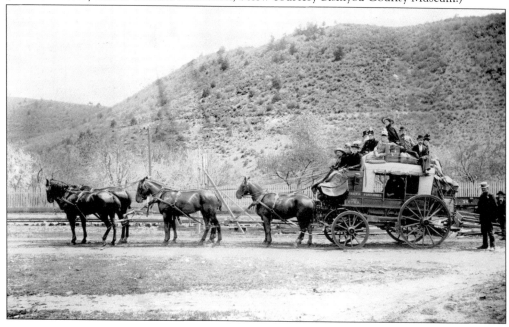

The locally well-known Anderson Grade was one of the first roads to head north of town. The Shelley Bridge was constructed in 1899 and helped travelers cross the Shasta River just outside of Yreka. There are numerous bridges of similar construction in the outlying areas; they were early pre-fabricated kits, and the parts arrived in pieces for locals to assemble. (Courtesy Yale East, copyright © 2006.)

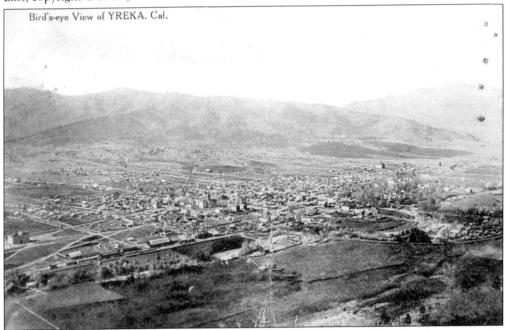

This card was mailed September 1, 1914, from Yreka. It states, "more forest fire this time at the further edge of the cemetery, luckily the wind is not in our direction if only it don't change we can see the flames from here. Lots of men out fighting it." Fire played a significant role in the daily lives of these residents of Yreka. (Courtesy Claudia East Collection.)

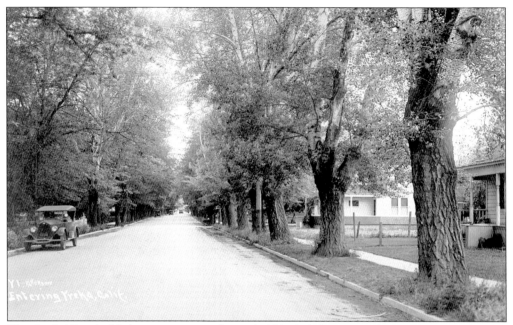

The shaded Pacific Highway, as seen in the mid-1920s, led the way to the city center and gave a welcome view to travelers entering Yreka. Beginning in 1933, this road was widened and paved, and it became known as Highway 99. The white house on the right is located at the corner of North Main and Howard Streets. (Courtesy Claudia East Collection.)

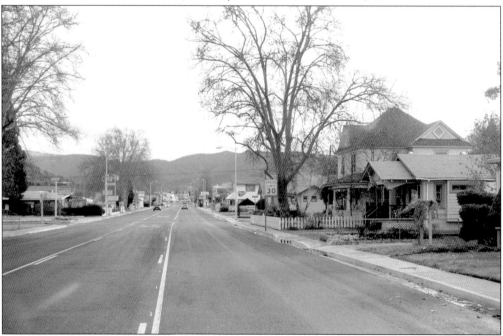

Above is a 2005 view of Yreka arriving from the north close to the city center along Historic Highway 99, also known as State Highway 3. The Victorian home on the right is the George E. Condrey house, built in 1908. The road has been widened several times, and the tree-lined view of earlier years has turned into sidewalks. (Courtesy Yale East, copyright © 2005.)

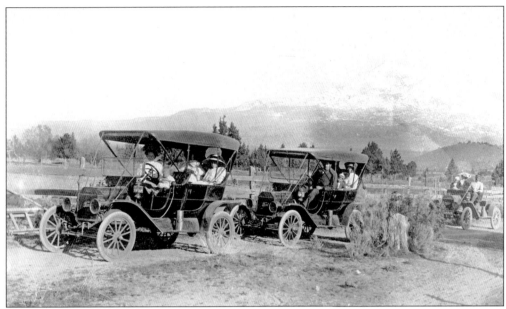

Three automobiles are photographed on an outing around 1915 with Mount Shasta in the background. One of the individuals has been identified as Edna Soulé. This was a critical time in America's history—as the automobile developed from a technological wonder into the standard for transportation, the development and maintenance of roadways became increasingly important. (Courtesy Siskiyou County Museum.)

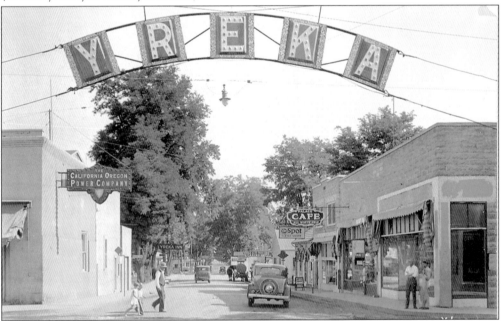

It was a different time and place in 1930s Yreka, when the café sign publicized "all white help." The Yreka arch once graced the corner of Main and Miner Streets. The only buildings that currently remain are the ones visible on the left; the former California Oregon Power Company building is now home to the Miner Street Pub, located at 102 West Miner Street. (Courtesy Claudia East Collection.)

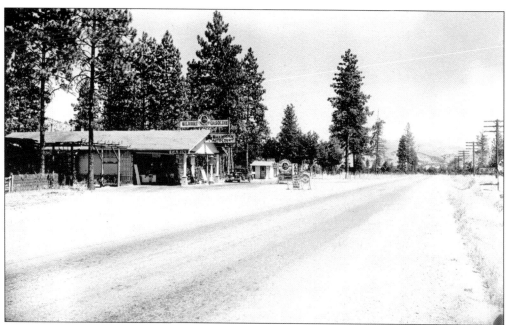

The Shamrock Auto Court and Gilmore gas station on the Pacific Highway are viewed with Mount Shasta in the background around 1928. As America took to automobile travel, auto courts sprang up where cabins, camping, ice-cold drinks, gasoline, and other sundries were made available. Eventually the Shamrock turned into a popular dinner house; though no longer open, the restaurant is still standing. (Courtesy Siskiyou County Museum.)

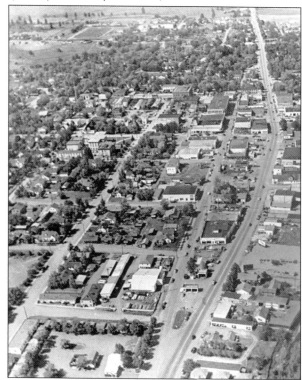

Observe the aerial view of Yreka at the "Y," photographed around 1940. Highway 99—Main Street—was in its prime and created vibrant business activity. To the north, it can be seen that town literally stopped at Yreka High School. Many of the buildings viewed have changed or have been razed. (Courtesy Siskiyou County Museum.)

In 1926, the Pacific Highway officially became U.S. Highway 99, and sections of this once-familiar road became Interstate 5 in the 1960s. The road originally went from the Mexico border to Canada. This is just one of the historic signs visible in Yreka along old U.S. 99, which goes through town as Main Street. (Courtesy Yale East, copyright © 2006.)

In 1926, the Pacific Highway was officially designated Highway 99, and construction began in Southern California first, finally working its way north. Looking through wire fencing, the image above, probably taken in the 1930s, shows a portion of Highway 99 under construction near the Yreka area. The highway became the lifeblood of the city, increasing transportation and shipping, tourism, and mobility. (Courtesy Siskiyou County Museum.)

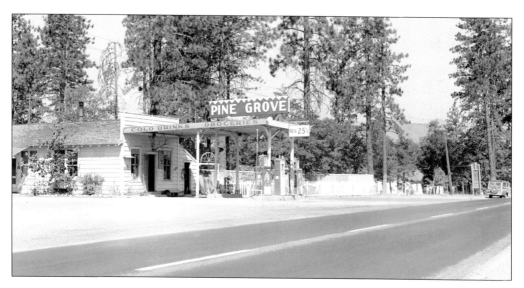

The Pine Grove Trailer Park was the quintessential early drive-in, full-service trailer park that also provided small one-room cabins as an alternative for travelers in the 1930s, 1940s, and 1950s. Located along the old Pacific Highway, which was later renamed Highway 99, it had an ideal location to provide services to travelers. The interstate has bypassed the park, and it now sits along Fairlane Road. A few remnants of this once-active tourist park remain, along with some permanent trailer residences. The last owners to operate the Pine Grove Trailer Park as shown in the photograph were Lloyd and Edna Watson. The Watsons included a small eatery within the building known as the Red Mill Café. Watson also operated an automobile-repair shop on the premises. (Above courtesy UC Davis Special Collections; below courtesy Thelma Visger Collection.)

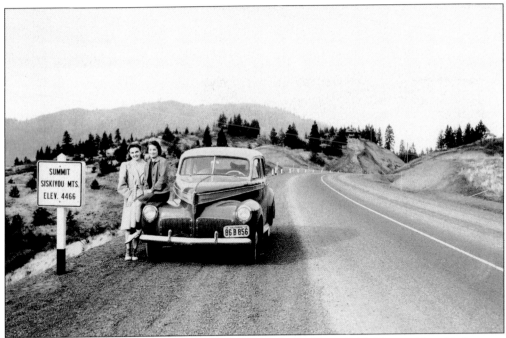

Above is a view of the Siskiyou Summit along Highway 99 in 1940. Two unidentified young women stand next to their Studebaker automobile. This image can give an idea of the width and condition of the major roads that went north from Yreka. Notice behind the car the small, short white posts—these were what served as a sort of guardrail system in that era. (Courtesy Siskiyou County Museum.)

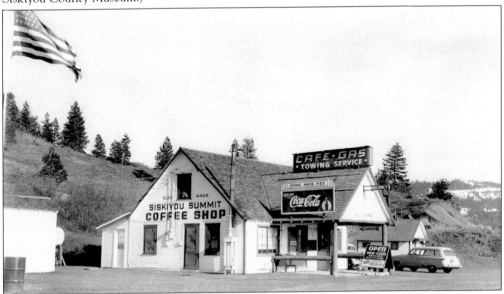

Traveling to Yreka from the north on Highway 99 meant crossing the Siskiyou Summit. The Siskiyou Summit station was a welcome sight to travelers. In winter, motorists could count on hot coffee and truckers would find respite. In the 1940s, Highway 99 saw rebuilding of the roads, and the actual high point of the highway changed by over 40 feet because of deep road cuts. (Courtesy UC Davis Special Collections.)

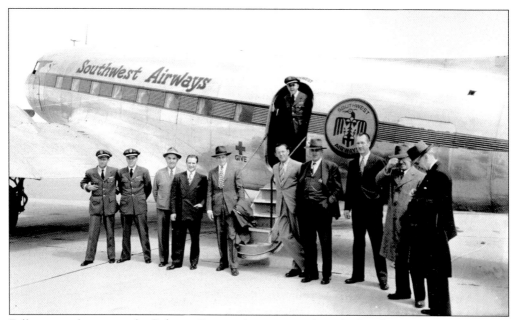

Following military use, the Siskiyou County Airport was a base for Southwest Airways from 1947 to 1953. Firefighting and private aircraft operations, as well as commercial ventures, were active during that time. At the right is a group of Yreka businessmen using the services of Southwest Airways. In 1949, an individual could fly one way to San Francisco for $12.55. (Courtesy Siskiyou County Museum.)

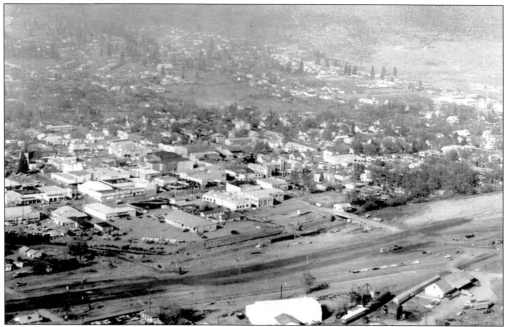

Above is an aerial view of Yreka showing the construction phase of Interstate 5. The change to the flow of Yreka Creek is evident, as is the new roadbed. Prior to the completion of Interstate 5, all traffic went through town on Highway 99. The interstate bypassed the major portion of the city when it opened in the late 1960s. (Courtesy Siskiyou County Museum.)

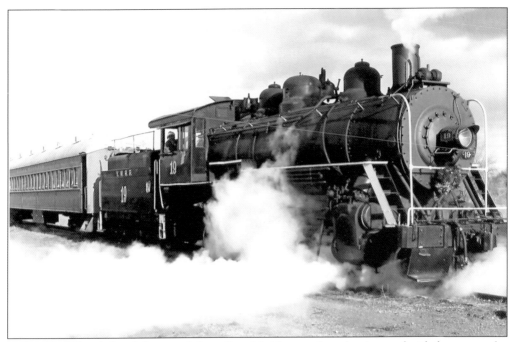

Yreka Creek flooded and destroyed the railroad bridge so often that it was decided to move the railroad station to the east side of the creek in 1910. The architecture was the same, but the new station was much larger. That station is still used today and is the headquarters for the Blue Goose Excursion Train and its gift shop. Tourists enjoy Engine No. 19, driven by engineer Dennis Woodruff, shown above, during the spring, summer, and fall, and townspeople enjoy special pumpkin and Santa Claus excursions at other times during the year. Yreka Western Railroad is still an active railroad company and is also based at the train station. It has one diesel engine, which is used for hauling wood products from local mills to the main line in Montague. (Above courtesy Mary O'Kelley Collection; below courtesy Karen Cleland Collection.)

Two

BUSINESSES IN TOWN

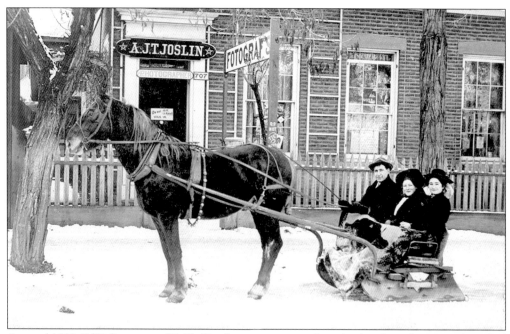

Around 1910, Ed Egli, owner of Egli's Confectionery, is out for a sleigh ride with two unidentified women. The building behind them is the Amon J. T. Joslin Photography Studio, located at 117 North Oregon Street (formerly numbered 707 Oregon Street), in the Pape-Stimmel Barham House built in 1858. (Courtesy Joanne A. Smith Mello Collection.)

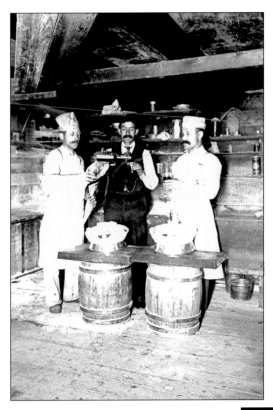

This beautifully decorated wedding cake was created at the Yreka Confectionery before 1900. The bakers (at left), shown from left to right, are an unidentified helper, Peter Esling, and Joe Esling; they appear to be toasting the cake's completion. The bakery, seen in the background, looks very primitive. Gold Rush towns often bloomed overnight and disappeared as soon as the gold ran out and the miners moved on. Many business owners followed the miners from boomtown to boomtown and only carried the tools needed to begin business in the new place. A new business could be established with a tent, some planks, and a few barrels. (Both courtesy Siskiyou County Museum.)

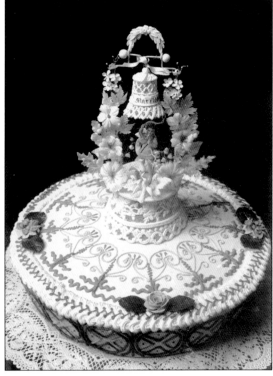

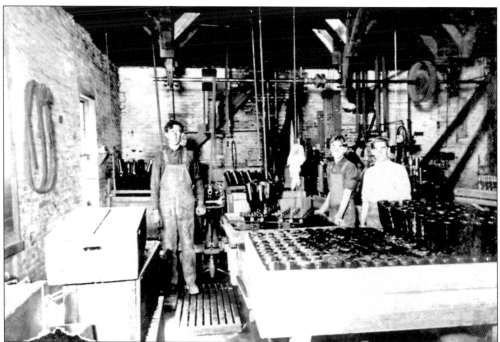

Meamber Bottling Works brewery's bottle-washing department is seen around 1900. The person in the center is identified as Mark Skomo; the other individuals are unidentified. Gus Meamber first entered the bottling business in 1897, when he purchased the existing Yreka Bottling Works. The works changed locations frequently for several years until about 1910, when they built their own building. Less than 10 years later, several others were built until they acquired the Coca-Cola franchise. Below is a photograph of one of the Meambers Coke bottles from Yreka. The bottles in the photograph above are likely the rare brown beer bottles that collectors eagerly seek out today. (Above courtesy Siskiyou County Museum, below courtesy Yale East, copyright © 2006.)

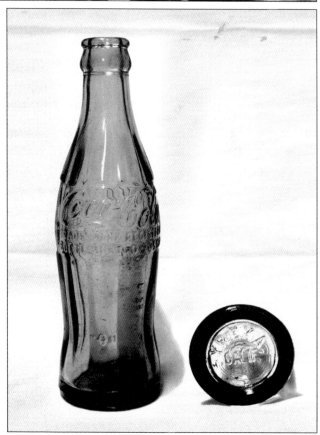

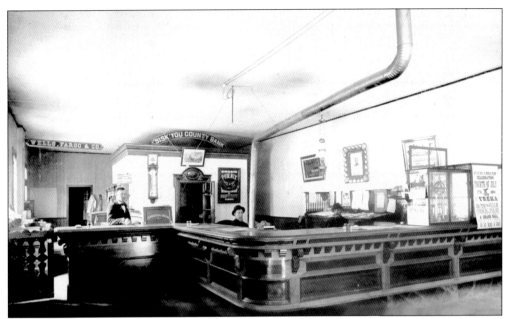

This 1893 photograph shows the interior of the Guilbert Building, home to the Siskiyou County Bank and Wells, Fargo, and Company. They shared this space beginning in 1886. The original portion of the building was built following the fire of 1871. In 1899, a second story and remodeling created what is seen today. Pictured from left to right are Charlie ?, H. B. Gillis, and Fred Wadsworth. (Courtesy Siskiyou County Museum.)

The Guilbert Building, on the corner of Miner and Third Streets, has gone through many changes and businesses over the years, but it is mostly known for the banks that served the community. The Siskiyou County Bank operated here from the 1890s and, through mergers and acquisitions, in 1930 became a Bank of America branch, which conducted business in this building until 1955. (Courtesy Claudia East Collection.)

This photograph shows businessmen of Yreka in the 1890s. From left to right are (first row) W. W. Powers, carpenter; William Bisbee, Yreka Gas Company; Levi Swan, carriage maker; and M. Sleeper, clerk; (second row) A. E. Raynes, merchant; A. E. Schwatka, mining superintendent; Dr. F. G. Hearn, dentist; and John Burgess, farmer, teamster, and sheriff. F. G. Hearn was with the Abraham Thompson party of men who were the first to discover gold on Yreka Flats. William Bisbee's Yreka Gas Company organized in 1856 and was located on Main Street near its intersection with Miner Street. Pitch pine generated the gas used to illuminate Miner Street, Fourth Street, and the courthouse, as well as some commercial and residential buildings. Levi Swan was well-known as a master carriage maker. A. E. Schwatka supervised the construction of the East Side Ditch in 1879. (Courtesy Siskiyou County Museum.)

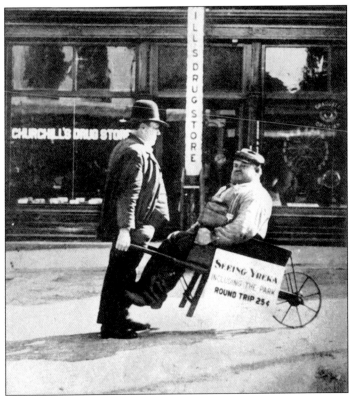

Churchill's Drug Store was an icon along Miner Street in Yreka for years. For many years the store advertised souvenir postals in great variety, which they produced, and they would mail 12 cards to any part of the state for 25¢. This photograph is from one that was mailed in 1908 and was clearly meant to convey humor. (Courtesy Joanne A. Smith Mello Collection.)

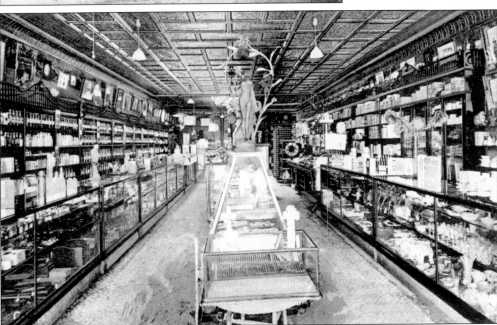

Shown is the interior of Churchill's Drug Store, located on Miner Street, around 1910. It wasn't until the 1860s that pharmacy changed from alchemy to scientific fact and medicine. The decoration and appearance of the store were important to assure the customer that all medicines dispensed would be of the highest quality. (Courtesy Siskiyou County Museum.)

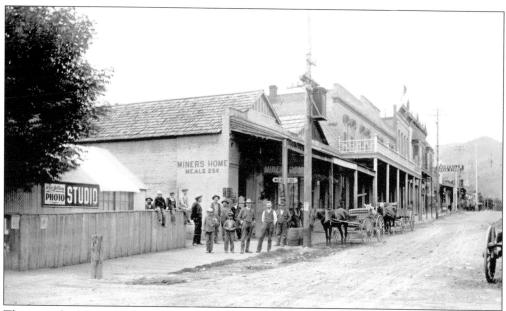

This view looks west down Miner Street at the corner of Broadway Street, previously named Second Street, in 1900. The Miner's Home was a very active establishment with a lobby, saloon, meals, and rooms available. Among the people in the photograph are M. Wacker, J. Bowers, P. LeMay, A. Morell, and G. Dixon. The building with the balcony to the west of the home is the Clarendon Hotel. (Courtesy Siskiyou County Museum.)

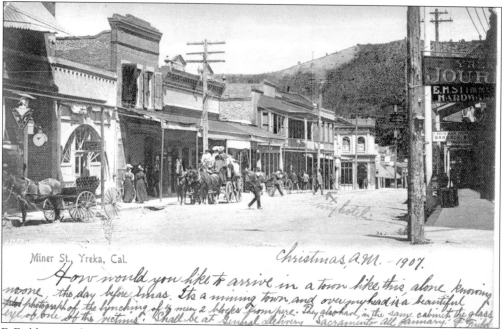

F. Field wrote this while staying at the Franco-American Hotel. "How would you like to arrive in a town like this, alone knowing no one, the day before Xmas. It's a mining town and over my head is a beautiful photograph of the lynching of men 2 blocks from here. They also have in the same cabinet the glass eye of one of the victims." (Courtesy Claudia East Collection.)

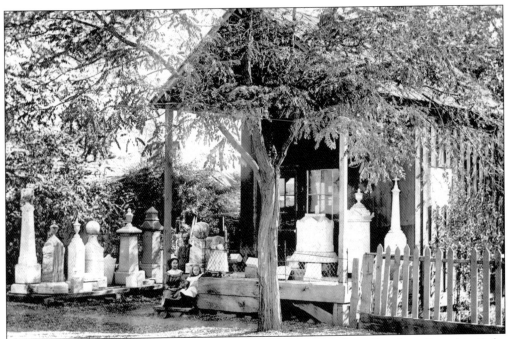

The J. B. Russell Marble and Granite Works at 404 Second Street (now Broadway Street) in Yreka was just north of the original Yreka Railroad train station. Russell's Marble Works began in 1885 and was destroyed by the 1886 fire. Russell rebuilt, and the above 1896 photograph shows Russell's fine monuments. The top photograph shows, from left to right, J. B. Russell and his children, Lelia Russell, Marie Russell, and Ashley Russell. The c. 1900 photograph of the interior of the shop, below, shows, from left to right, James McCoy, and Mildred Russell. The family home at 408 Second Street lay beside the business. (Courtesy Harvey Russell Collection.)

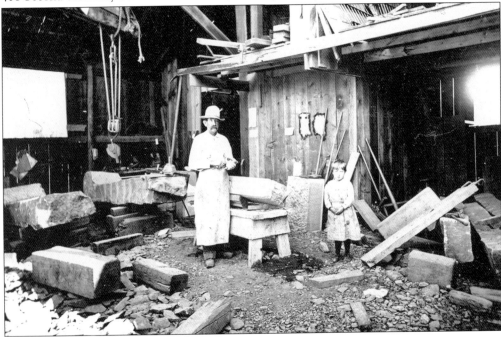

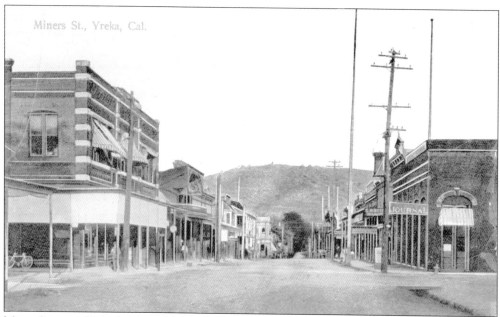

Miner Street in Yreka has been the center of business activity for 150 years. Although this image was taken around 1907, much of the street still appears the same today. Yreka, along with other towns in Siskiyou County, were early to adopt electrical power. A special brochure created for the 1915 Panama International Exhibition in San Francisco stated that Yreka was "abundantly illuminated." (Courtesy Claudia East Collection.)

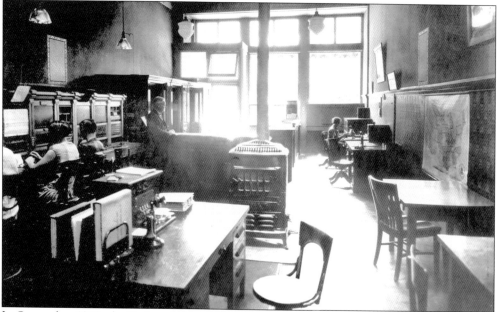

In September 1898, the Yreka telephone exchange and first switchboard were installed at 210 West Miner Street. Cina Tyler, pictured at right, managed the Yreka telephone office from that day until 1931. W. D. Nunamaker, center, was wire chief. Located at the switchboard, from left to right, are Grayce McCarthy Beal, Elizabeth Gibeson Girard, and an unidentified woman. By 1908, there were nearly 200 telephones in use. (Courtesy Siskiyou County Museum.)

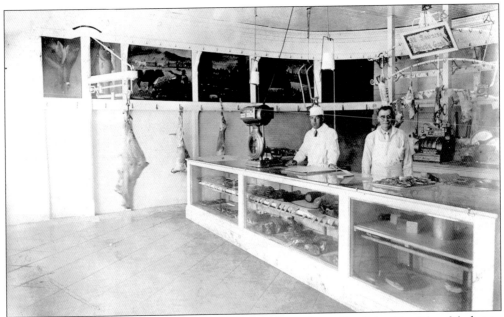

Traveling artist A. Cedros painted the murals visible on the walls of the City Meat Market in 1911. The City Meat Market was in operation from 1854 until 1973, and the business was kept vibrant by regular improvements, such as lower prices to reduce competition, screens to keep out insects, an ice plant, and in 1897, electric-light globes that spelled out "City Market." (Courtesy Siskiyou County Museum.)

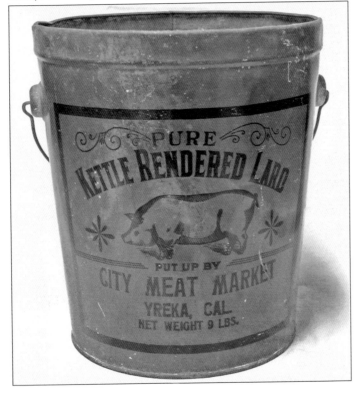

A local consumer purchased this nine-pound can of pure kettle-rendered lard put up by the City Meat Market in Yreka. Lard is richer than many other fats and therefore makes extremely tender, flaky biscuits and pastries. Kettle-rendered lard is usually made from pure leaf lard, the highest quality offered. (Courtesy Yale East, copyright © 2006.)

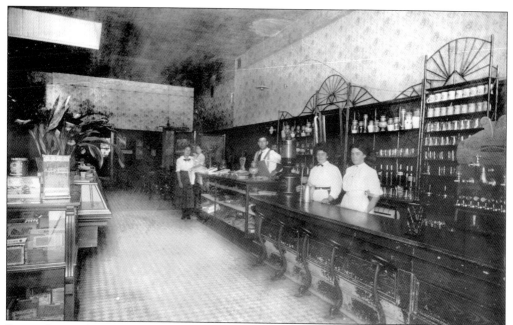

Pictured around 1917 is the interior of the Egli's Confectionery, located at 323 West Miner Street in a portion of what is now Don's Sporting Goods Store. Pictured are, from left to right, an unidentified woman and child, Ed Egli, Louise Egli, and Verna Wilson. Prior to Ed Egli operating the store, this location was known as the Dorn Ice Cream Parlor. (Courtesy Joanne A. Smith Mello Collection.)

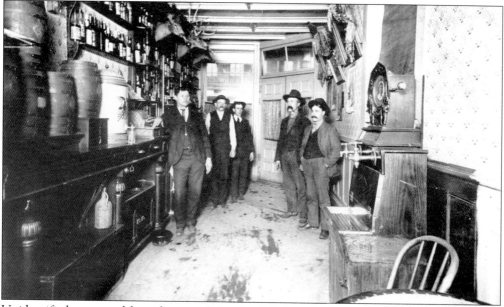

Unidentified men stand for a photograph in what is believed to be the Eagle Saloon at 311 Miner Street around 1910. Through the window, the balcony of the Franco-American Hotel can be seen. During this time, there were several such enterprises along Miner Street ready to serve a paying customer. Note the deer heads on the wall; they have electric light-bulb fixtures in their mouths. (Courtesy Siskiyou County Museum.)

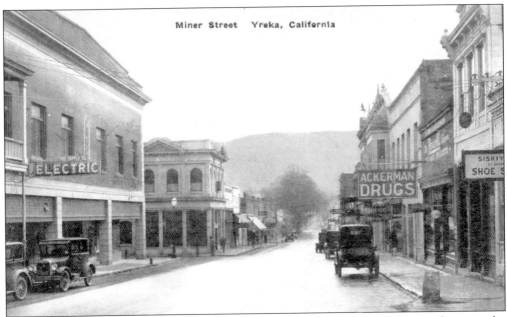

Miner Street Yreka, California

A view of the Electric Supply Company can be seen on the left as one of the merchants in the ground level of the Masonic Building around 1928. In the far distance, the Yreka archway is just visible. Other merchants on Miner Street at this time include Ackerman Drugs, Siskiyou County Bank, Clarendon Hotel, and the Siskiyou Shoe Shop. (Courtesy Claudia East Collection.)

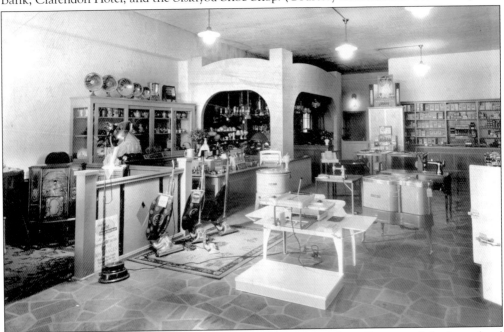

In 1926, the Masonic Lodge built a new building at 304 West Miner Street, and the lower level was designed for business rentals. Ernest Millbourn owned the Electric Supply Company when he rented one of the business spaces available. Looking closely at the interior, one can view General Electric appliances that were the latest in innovation for the time. (Courtesy Siskiyou County Museum.)

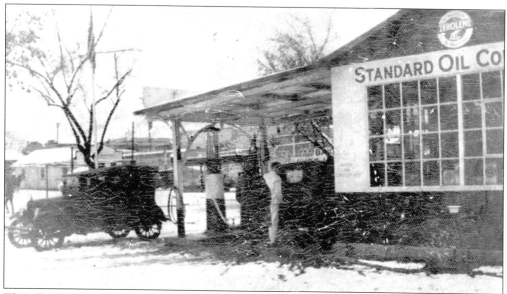

There has been a gas station at the corner of Main and Center Streets for over 80 years. This is a view of the Standard Oil Station is from 1926. On the side of the building is a small round sign that advertises Zerolene, a lubricant that got its name because the company promoted it would flow freely at a temperature of zero. (Courtesy Jim Brooks Collection.)

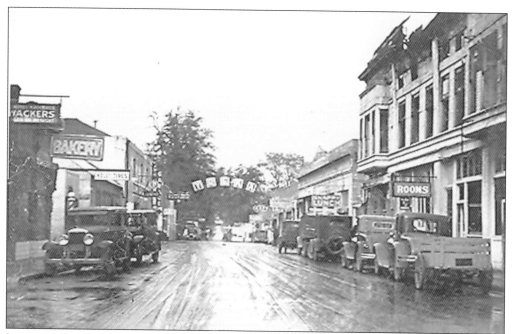

It was 1929 when the above image was taken of Main Street near the city business center. A few years after this photograph, the street was widened and the archway was removed. The sign on the left that shows Wackers is currently the Ace Antiques location, and all the buildings viewed on the right side of the photograph are gone. (Courtesy Claudia East Collection.)

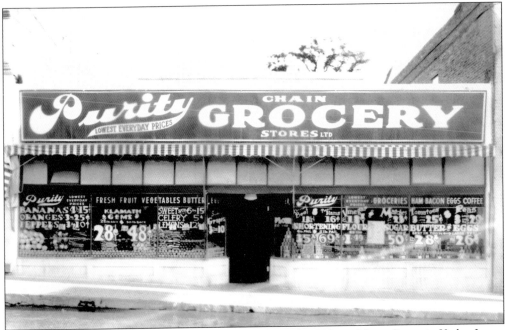

The Purity Grocery Store is seen as it appeared in the early 1930s on Miner Street in Yreka. It was located in the building commonly referred to as "Blacks" by longtime residents today. By 1939, it was located at 309 South Broadway Street in a new building that had the recognizable arch shape of the Purity Chain. The first Purity store was established in 1929 in San Francisco, and the chain continued to be operated by the Niven family until 1972. On the shelves behind the clerks are brand names familiar to many today: Wheaties, Kellogg's Pep, Post Toasties, and other breakfast cereals. Tasty brand mayonnaise is located in a neat stack just behind the bananas that are available at four pounds for 15¢. (Both courtesy Siskiyou County Museum.)

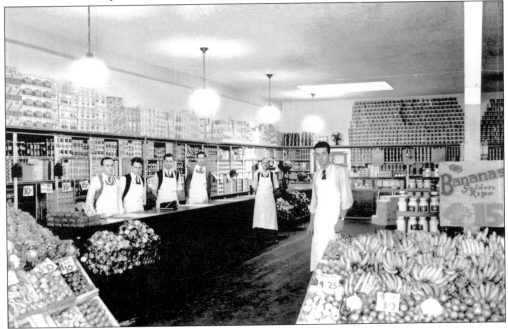

A distinctive 1930s view of Broadway Street looking south from the Miner Street corner gives a glimpse of life as it once was. On the right is the Warrens Building, one of Yreka's former notable landmarks. On February 11, 1966, fire broke out in the second floor and destroyed the entire top portion of the building. A malfunction in the furnace was the suspected cause. (Courtesy Siskiyou County Museum.)

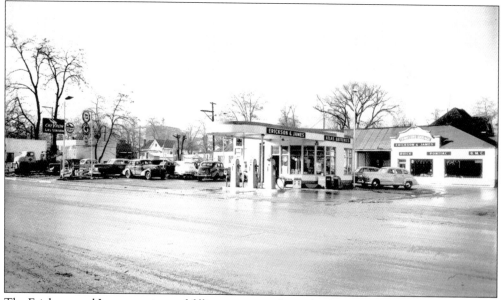

The Erickson and James service and filling station and travelers' garage was located at 221 North Main Street in Yreka, directly on the Highway 99 corridor, and provided sales and service for Buick, Pontiac, and GMC automobiles. The station was less than a block from the Yreka Inn and had an opportunity to serve travelers and locals alike. The photograph was taken around 1950. (Courtesy Siskiyou County Museum.)

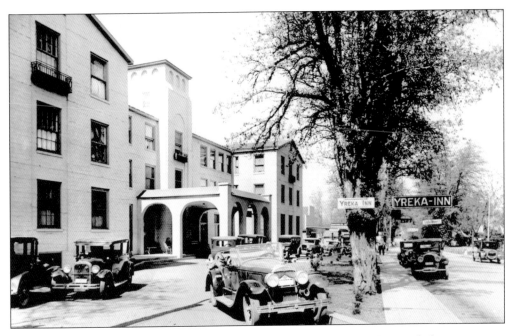

The Yreka Inn, built in 1925, was located at 117 North Main Street. Pictured above is a view of the building in its heyday, and below is a view of the lobby of the hotel. It was touted as a first-class commercial and tourist hotel and included an adjoining restaurant with a dining room and ballroom. It was reported that people from many areas came for the good food, music, and dancing. The hotel was first owned and operated by L. L. and W. J. Weaver. Unfortunately, after years passed, the inn closed some rooms, and the business became less profitable. In late 1975, the hotel was demolished to make way for a new bank building that first operated as Timberline Bank. (Above courtesy Siskiyou County Museum; below courtesy Claudia East Collection.)

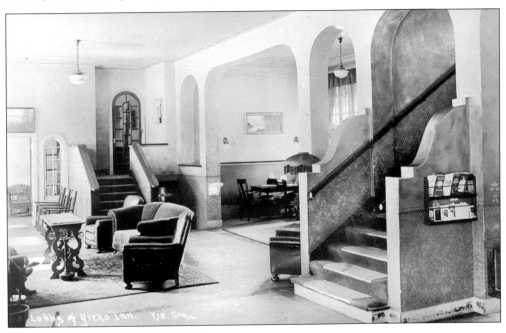

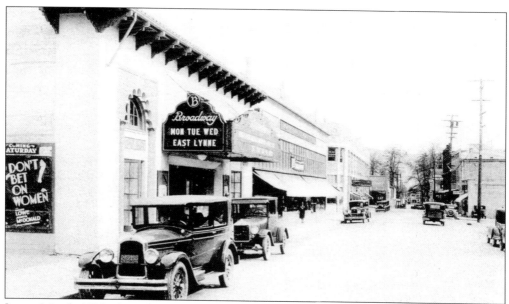

It was March 1930 when the contract was made to build the Broadway Theatre in Yreka for $75,000. This photograph was taken about a year after its completion, as the movie *Don't Bet on Women* came out in 1931–1932. Bernice Warrens, sister to Victor E. Warrens, owned the Broadway Theatre at the time this photograph was snapped. (Courtesy Claudia East Collection.)

REMEMBER · V-E-DAY · TUESDAY, MAY 8 · 1945
NOW FOR FINAL VICTORY

Watch for Two Big Events Coming

Siskiyou County Bond Queen Contest
SPONSORED BY YREKA 20-30 CLUB
With Coronation At The
BROADWAY THEATRE
and
THE GALA BOND PREMIERE

JUDY GARLAND
ROBERT WALKER
in
The CLOCK
with
James Keenan Marshall
GLEASON · WYNN · THOMPSON

Admission
ONE
WAR
BOND

A patriotic promotion by the Yreka 20-30 Club and the Broadway Theatre required the admission of one war bond. It was 1945, and war bonds were a form of savings bonds used to help fund World War II. In addition, the bonds also provided a way to manage inflation by removing money from the economy fueled by the war effort. (Courtesy Claudia East Collection.)

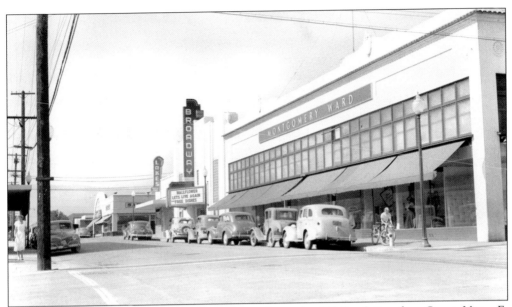

The Montgomery Ward store, pictured in 1948, was located at 201 South Broadway Street. Victor E. Warrens erected the building expressly for Montgomery Ward. Warrens also constructed the Ward building in Redding. About 10 years before this photograph was taken, a copywriter for Montgomery Ward Corporation created the character of Rudolph the Red-Nosed Reindeer for an advertising campaign, and it has become a Christmas icon. (Courtesy UC Davis Special Collections.)

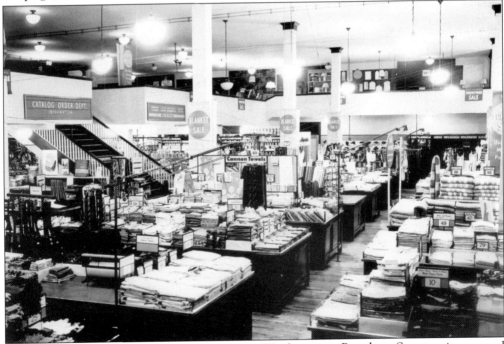

The interior view shows the Yreka Montgomery Ward store on Broadway Street as it appeared around 1945. Victor E. Warrens originally built this building, the same individual of the Warrens Building fame just up the block. Montgomery Ward was the very first dry-goods mail-order catalog business; it created its first single-page catalog in 1872. (Courtesy Siskiyou County Museum.)

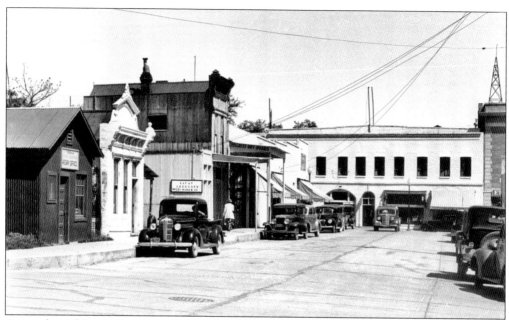

A snapshot of Fourth Street near Miner Street, about 1940, appears above. The Franco-American Hotel sits at the end of the street and appears updated from its Victorian days. The small white building on the left was actually the top of the former Pashburg store, which once stood on a portion of Fourth Street at Miner Street and was torn down in 1931, when Fourth Street was widened. (Courtesy Siskiyou County Museum.)

The Nugget Auto Court was located at 827 South Main Street in Yreka around 1940. This auto court was located along Highway 99 close to the center of town and served travelers with cozy accommodations. The court encompassed the entire block between Yreka Street and Jefferson Street (now Dillon Way). In the early 1960s, the new Safeway store was built here. (Courtesy Siskiyou County Museum.)

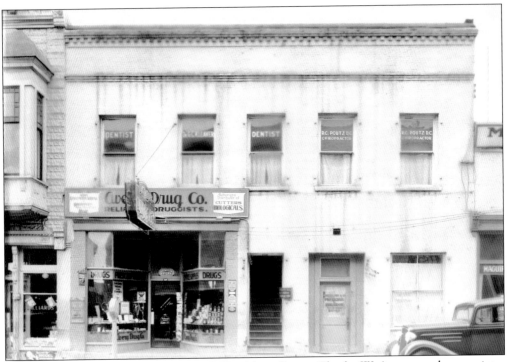

Avery Drug Company was located at 225 West Miner Street. Charles W. Avery was the proprietor and druggist in 1900. In the c. 1930 view above, Avery Drug advertises McKesson products as well as Kodak photo finishing, and customers are greeted with a rack of magazines on the door. The business flourished for many years, and a more modern view of the interior of the store can be seen below during Valentine candy sales in 1951. At this later time, a wide variety of products were available. At the end of the counter is a rack of Rit fabric dye, and along the wall is a rack of brochures giving information on vitamins. (Both courtesy Siskiyou County Museum.)

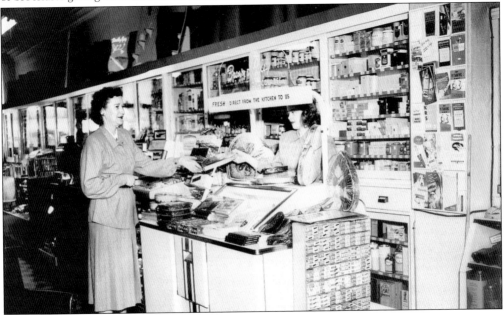

It was 1909 when Anna C. Lake first rented a store on Miner Street and opened for business as the Lakonian, specializing in hats and lingerie. In 1939, Lake's Jewelry and Dress Shop was located at 315 and 317 West Miner Street; later that year, Lake built the store that stands at 216 South Broadway Street next to the theater building. In 1949, Ralph W. and Mary E. Lake took over the business. In 1966, the management was given to Ben and Virginia Wilmarth. Lake's Jewelry and Dress Shop continued to have an excellent reputation for quality and service for nearly 90 years. (Above courtesy UC Davis Special Collections; below courtesy Siskiyou County Museum.)

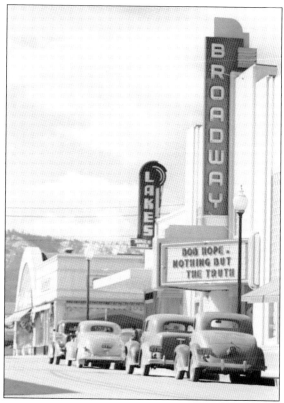

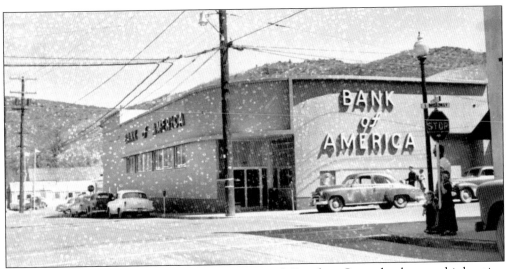

The Yreka branch of the Bank of America, at 200 South Broadway Street, has been at this location since March 7, 1955. The photograph above shows the Main Street entrance as it appeared when the building was new. The building underwent a face lift in the 1970s and continues to serve its patrons today. (Courtesy UC Davis Special Collections.)

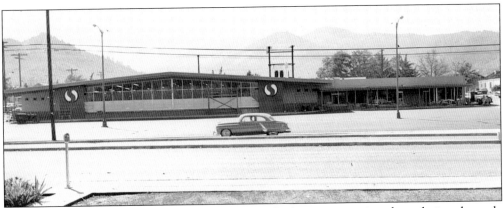

The first supermarket-style Yreka Safeway, seen in the late construction phase during the early 1960s, was located at the corner of Main Street and Dillon Way at the Y. The Safeway name first came into use in 1914, but Safeway as it is known today came into being with a merger in 1926. (Courtesy *Siskiyou Daily News*.)

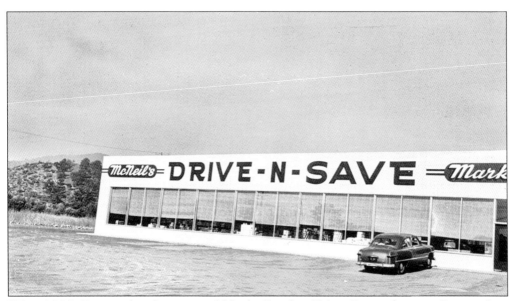

When McNeil's opened at the corner of Oberlin Road and Main Street, the name Drive-n-Save fit nicely. One had to drive to the edge of town to get to this market; the building is still standing and currently houses the Check and Go Company. At the time McNeil's was built, Yreka's drive-in movie theater was behind it and to the west. (Courtesy Siskiyou Golden Fair.)

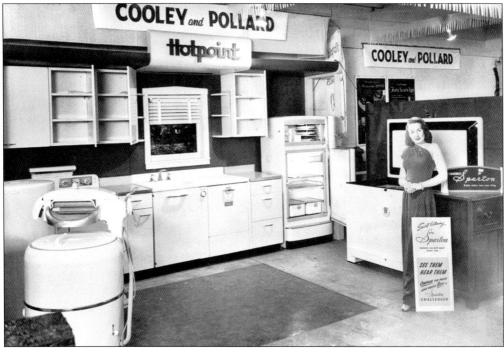

The name Cooley and Pollard has been an icon in Yreka since Valentine's Day 1924. The two partners began a sporting goods store at 313 West Miner Street but moved to their present location at 300 West Miner Street and expanded into hardware about 1928. The photograph above is a Cooley and Pollard display at the Siskiyou County Fair in 1953 or 1954. (Courtesy Siskiyou Golden Fair.)

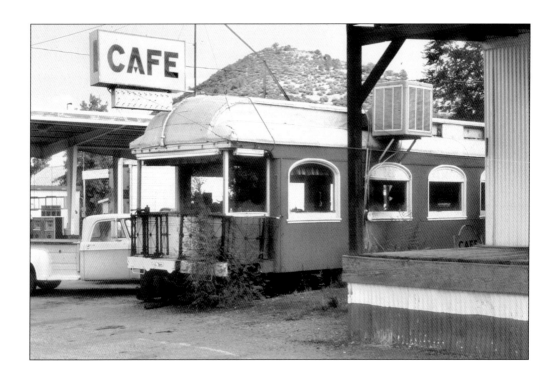

The Diner provided a staple of Yreka's restaurant fare from the 1950s until 1986, when it closed its doors. Located on an old rail spur along Yreka's Main Street, it served food to locals and travelers 24 hours a day. The train car arrived at Yreka in 1945 following the closing of the Yosemite Valley Railroad. The car was ordered in 1907 from Hick's Locomotive and Car Works of Chicago and was numbered YV 330. It first served as an observation car for the train traveling from Merced into Yosemite National Park. After the Diner closed, it sat in the city corporation yard for nearly 12 years, as seen below. In 1995, the car was purchased for $1 from the city; since then it has been undergoing total restoration. (Above copyright Glen Joesten; below courtesy Jack Burgess, copyright © 1994.)

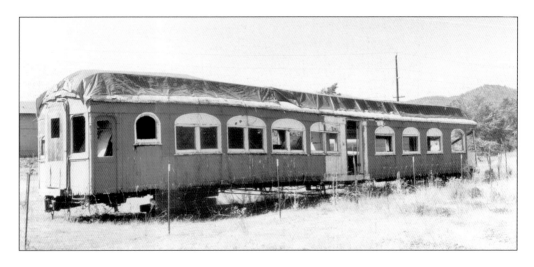

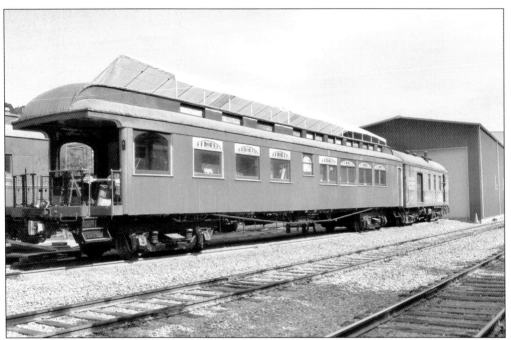

Pictured is the former Yreka Diner as it appears today. The new home of the past icon is at the Niles Canyon Railway in Sunol, California. The restoration process is scheduled to be complete by the time this book goes to press. Wes Swift, his wife Claudia Swift, and Jack Burgess, as well as a host of other volunteers, have spearheaded this labor of love. (Courtesy Jack Burgess, copyright © 2006.)

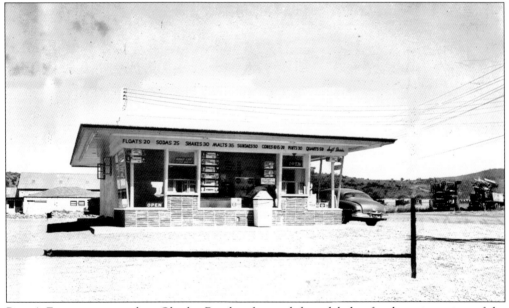

Peggy's Freeze once stood on Oberlin Road and served their delights for the going prices of the day—milk shakes 30¢, floats 20¢, and ice-cream cones 10¢, 15¢, and 20¢. The building was later remodeled, and the business was called Grants Boys. When the interstate came through Yreka at the Oberlin interchange, the building was razed. (Courtesy *Siskiyou Daily News*.)

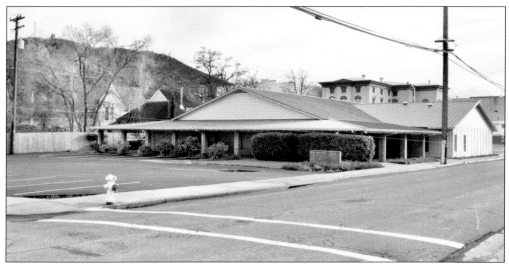

Daniel H. Girdner founded the Girdner Funeral Chapel and ambulance service in 1943. His son joined the business in 1954. The original chapel was located where the parking lot is today. In 1970, the Girdners constructed this new facility at this location on Oregon Street. Behind the building, the older portion of the county courthouse can be seen. (Courtesy Yale East, copyright © 2005.)

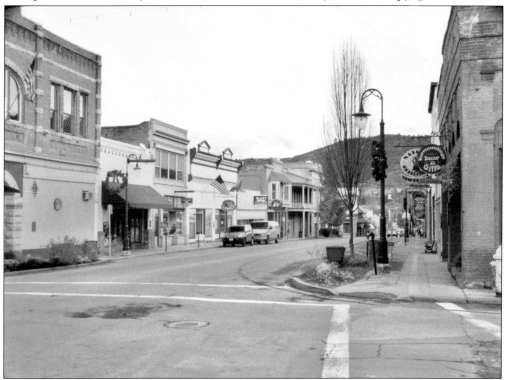

This is a view down Miner Street looking east from the corner of Oregon Street in 2005. At the left is the building occupied by the Elks Lodge since 1980. Other businesses along the left side of the street are, from front to back, Foster Parent Agency, Angelini's Italian Restaurant, and Black's Appliances; on the right, Surroundings Décor and Gifts, Natural Selections, Don's Sporting Goods, and Nugget Printing can be seen. (Courtesy Yale East, copyright © 2005.)

Three

HOMES, LIBRARIES, CHURCHES, AND CEMETERIES

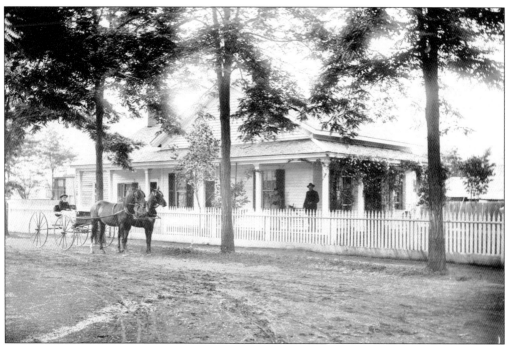

Pictured above is the J. E. Harmon and Nellie Harmon residence as it appeared in 1893. The residence is located at 602 Lane Street in Yreka and stands proudly today. The person in the buggy is identified as the Harmons' son Ernest, when he was about 12 years of age. J. E. Harmon was the owner of a livery stable in town. (Courtesy Siskiyou County Museum.)

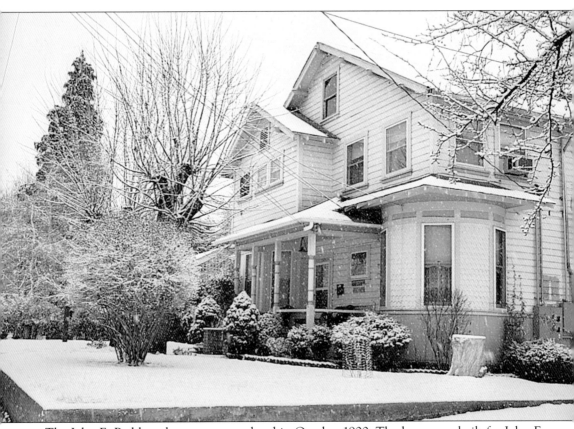

The John E. Pashburg home was completed in October 1900. The home was built for John E. Pashburg and his new bride, Mable Rogene DeWitt. They were married and moved directly to their "handsome new home just completed on Oregon Street, opposite the High School," according to a news article in the *Yreka Journal* from October 18, 1900. John E. Pashburg served as the county tax collector for a number of terms as well as being in partnership in a grocery store on Miner Street with his brother-in-law. The Pashburgs lived in this house until about 1928. The home originally had a smaller upstairs with one bedroom and a bath. Tragedy occurred here on August 9, 1934, when a fire broke out in the upstairs and a tenant who was renting a room at the time died because of the blaze. The top floor was later rebuilt and remodeled into two apartments. (Courtesy Donald Y. East, copyright © 2002.)

This plate was hand painted by Henrietta Pashburg (1876–1971), a native of Yreka. Henrietta was the daughter of one of the first merchants in Yreka, John Pashburg Sr., who arrived prior to 1861. Henrietta moved to San Francisco in later years and owned and operated a small art studio, where she sold her painted china. She continued in the operation of her business and art for many years. (Courtesy Claudia East Collection.)

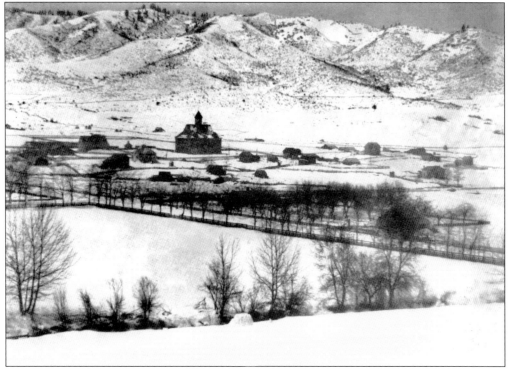

It was 1905 in the moonlight when this photograph was taken with a time exposure of the north end of Yreka in view. The large building near the center is the original Siskiyou County High School with surrounding homes and streets. The corner at left is the intersection of Main and Lennox Streets, with Yreka Creek in the forefront. (Courtesy Siskiyou County Museum.)

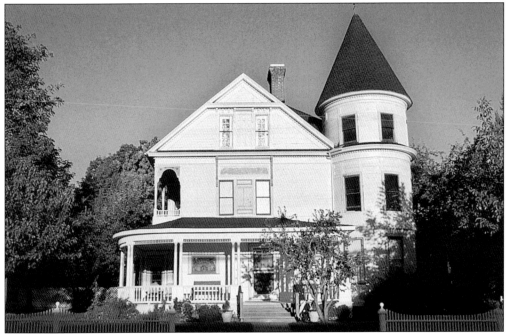

The H. B. Gillis House was constructed in 1895 and is located at 223 North Oregon Street in Yreka. This home has had a Hollywood past, including a Western film starring Chuck Connors in the 1960s, and it was featured in a segment of the television program *If Walls Could Talk* that was broadcast on the Home and Garden television channel during the 2004 season. (Courtesy Donald East, copyright © 2002.)

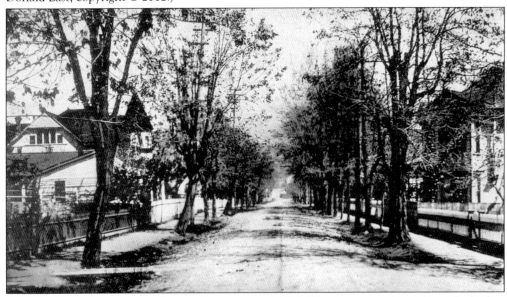

This picture looks north on Oregon Street around 1907. The house on the right with the bay windows was originally the Fred Autenreith home, which was built in 1890. On the left, the tower of the H. B. Gillis house, built in 1895, is visible, as well as the third-story windows. These two homes mentioned are still standing today and appear very much the same. (Courtesy Claudia East Collection.)

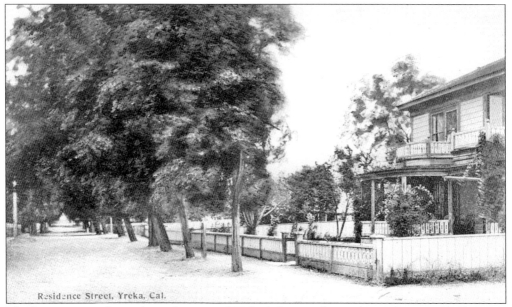

Residence Street, Yreka, Cal.

The house pictured at right is the original F. S. Ackerman home, located at 419 Third Street. This home was built in 1879 using materials reclaimed from a nearby house that was being dismantled. Ackerman kept the design of the home similar to the original. (Courtesy Claudia East Collection.)

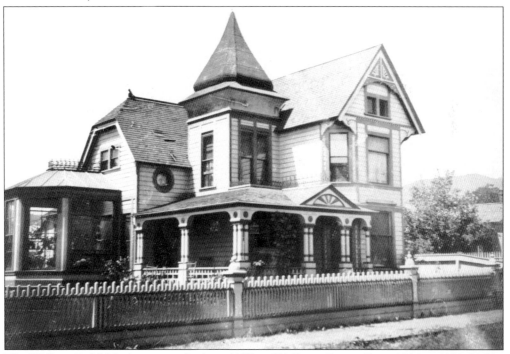

The William L. Hobbs house was built in 1897 at 501 Butte Street. From 1894 to 1898, Hobbs served Siskiyou County as sheriff. While in office, Hobbs experienced difficulty, through no fault of his own: a mob lynched four prisoners, and a deputy and a constable died in the line of duty. Following his term, he earned his living as a rancher. (Courtesy Siskiyou County Museum.)

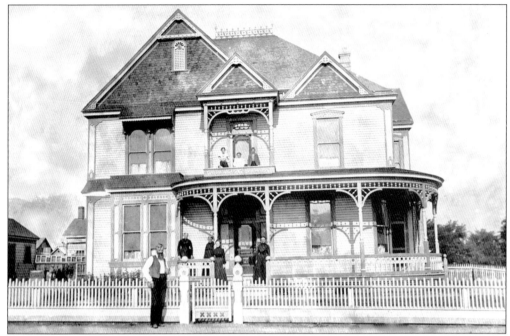

This lovely Queen Anne Victorian home graced Oregon Street from the front and sat on the southwest corner of Butte Street. It was originally a Koester family home built around 1890. This home was razed between 1965 and 1980, and currently a parking lot for county employees occupies this space. (Courtesy Siskiyou County Museum.)

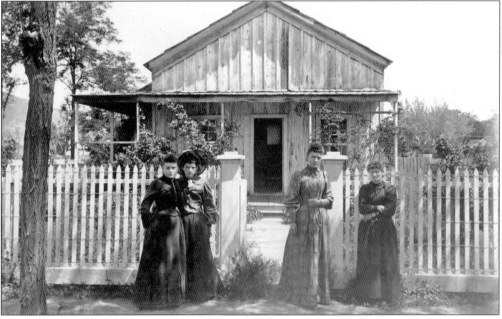

Pictured in this c. 1880 photograph is the home of Charles R. Herzog, reportedly located on Oregon Street. Herzog was manager of the Franco-American Hotel in Yreka for 15 years and later was engaged in real estate. Shown in the photograph are, from left to right, Mollie Shell, Zula Herzog (Mrs. Charles R. Herzog), Clara LeMay, and Amelia Ranus. (Courtesy Siskiyou County Museum.)

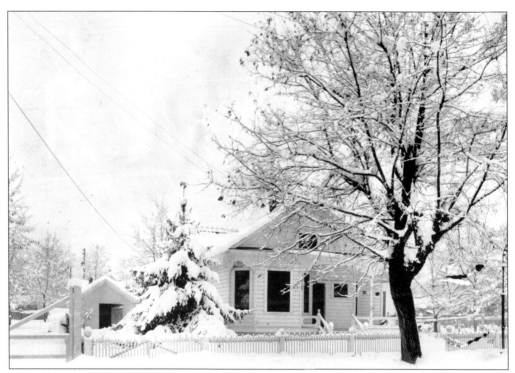

The George A. Tebbe house is pictured during winter. The house was located at 419 West Miner Street, which would have been adjacent to the current Lay Station Fire House and Museum. Tebbe was a prominent attorney and was in partnership with the firm of Tebbe and Correia at 201 Fourth Street. (Courtesy Siskiyou County Museum.)

In 1899, Charles B. Fry had this home built at 216 Third Street by J. H. Ranous. Originally there was another house on the lot, but it was deconstructed and the parts were sold to make room for this new home. There is a sandstone walk in front of the house, which was laid in 1880, when the first home occupied this spot. (Courtesy Siskiyou County Museum.)

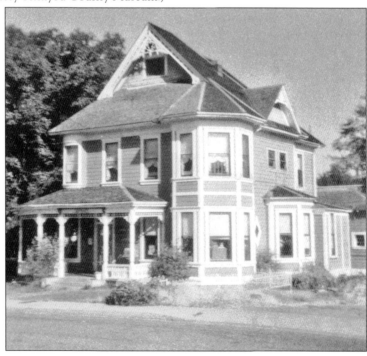

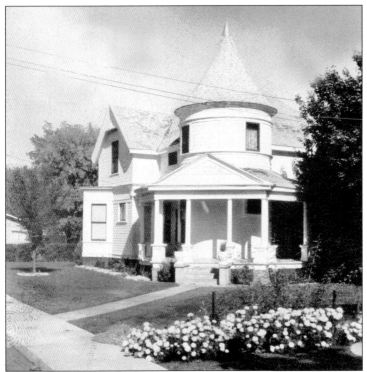

The Parr-Steele house is located at 415 Third Street, in the National Historic District. The builder, Dr. William Parr, designed the house as well as the unique spiral staircase that leads to the second story, and he contracted to have the home built for $2,500. Just five years after being erected in 1900, the home sold for $3,000. (Courtesy Siskiyou County Museum.)

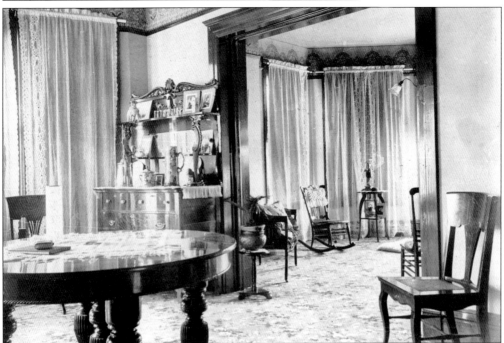

This is a c. 1905 view of the Charles E. Dorn house located on the northwest corner of Oregon and Lane Streets. Homes of this period were a reflection of the new middle class and a consumer economy. Rules of etiquette would require a dinner guest to place a spoon in their saucer to indicate they wished to be served more tea or coffee. (Courtesy Siskiyou County Museum.)

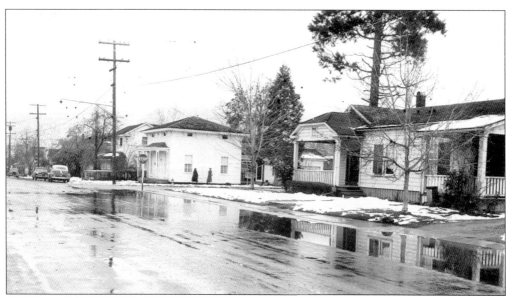

A wintry and wet picture was taken at the corner of Lane and Gold Streets in Yreka around 1950. The white home in the middle of the photograph is the original Frances M. Ranus house, built in 1857. The building on the right is a small apartment building at 603 and 605 Lane Street. (Courtesy Siskiyou Daily News.)

This is the Von Jochumsen-Meamber House, built in 1912. Von Jochumsen built the home while he worked as a chemist in Yreka for a local drugstore. Within a short time, Fred J. Meamber purchased the home, and it has remained in the family ever since. Fred J. Meamber Jr. and his wife, R. Bernice Soulé Meamber, served as Yreka's foremost historians for many years. (Courtesy Yale East, copyright © 2006.)

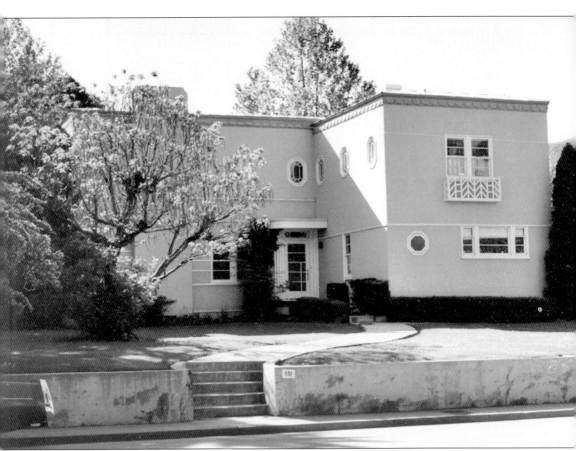

In 1934, Randolph Collier (California state senator, 1938–1976) had this 3,000-square-foot home built at 551 North Main Street in Yreka. All of the features of the home, both inside and outside, had strong art deco styling and characteristics. Originally the house was painted a cream color with green trim, but the color of choice by owners for the last 40 years has been pink. In the back yard, a swimming pool was dug by hand by a local man during the Depression; he was paid $1 a day for his labor. During the 1930s, the pool was filled once a week in the summer, as there was no filtering system, and the water drained from the pool was used to water the yard. The photograph above was taken in 1980, and the home appears very much the same today except for the planting of trees and other shrubbery in the front yard. (Courtesy Donald East, copyright © 1980.)

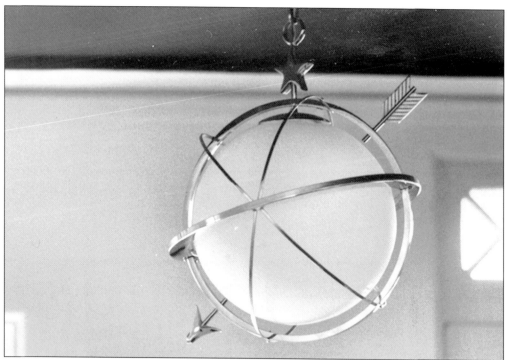

This light fixture originally graced the entrance, located above a curved staircase, at the art deco–style home of former California state senator Randolph Collier when he resided on North Main Street. This chrome-and-frosted-glass light fixture was from the 1933–1934 World's Fair in Chicago. (Courtesy Donald East, copyright © 1980.)

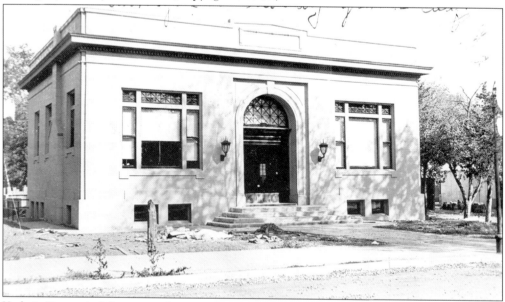

Yreka's Carnegie Library was begun in 1914. The photograph above shows the building at completion, but some of the construction debris is still noticeable in the forefront of this image. The Carnegie Foundation gave a grant of $5,000 to the City of Yreka for this library, located on West Miner Street near the Oregon Street crossroad. (Courtesy Claudia East Collection.)

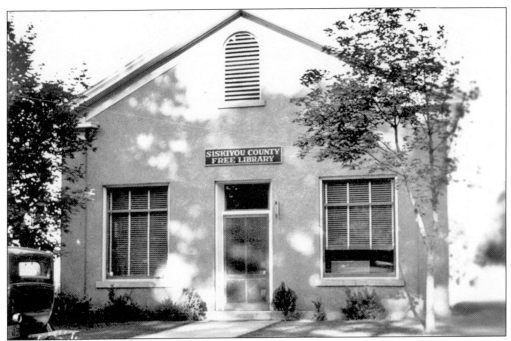

On May 3, 1915, the board of supervisors established the county library, and the first librarian appointed was Margaret Dold. In 1927, the library received permission to move into the building pictured above, once located across from the courthouse on Fourth Street. This building was originally built as the jail; after 1900, it served as the Agricultural Hall and the Forest Reserve Building before functioning as the County Free Library from 1927 to 1969. The main reading room is pictured below as it appeared in 1938. Yreka showed foresight in establishing a county library during difficult times in World War I as well as having an already-established Carnegie Library. The two libraries were separate until a merger began in 1967. (Both courtesy Siskiyou County Library.)

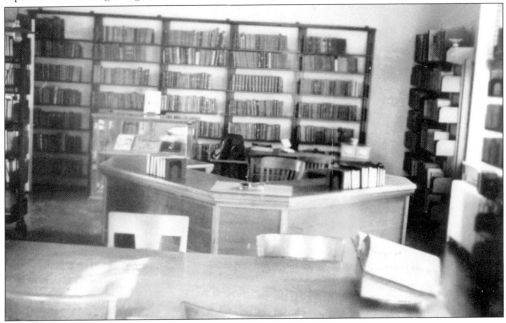

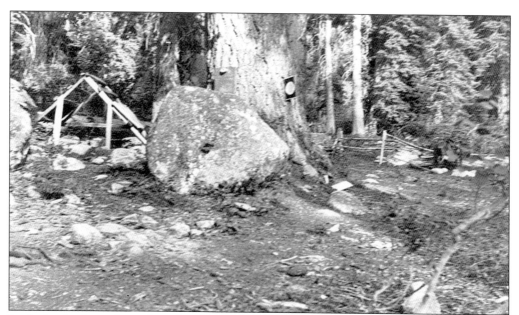

Look closely above the rock at the old dynamite box attached to the tree; nearby is a sign with a circle. The sign is for the Siskiyou County Free Library, and the box was the "library." A note discovered with the photograph states, "July 1922, Herbie's Circus Branch of the Siskiyou County Free Library." Miners would take and return books to the box on the tree. (Courtesy Siskiyou County Library.)

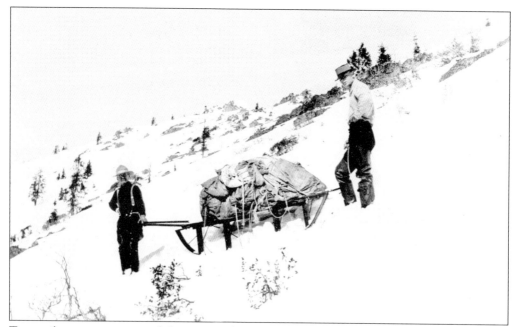

Two mail carriers are pictured above not only carrying first-class mail but also transporting library books to more remote locations, where heavy snow was apt to make travel difficult for long periods of time in winter. These books would be delivered to the branch libraries in the area. (Courtesy Siskiyou County Museum.)

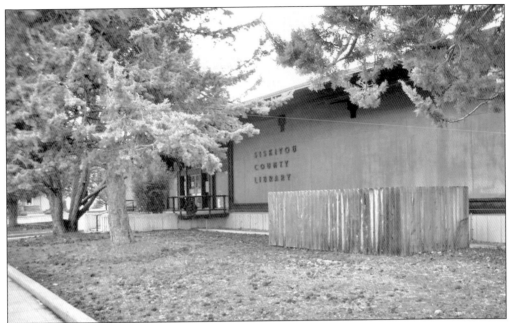

The current Siskiyou County Library has served patrons at this location for the past 37 years. It stands at 719 Fourth Street in Yreka. The building was officially dedicated to the people of Siskiyou County on April 26, 1970. It was during this time that the former Carnegie Library, locally known as the Yreka City Library, merged with the Siskiyou County Library. (Courtesy Donald Y. East, copyright © 2006.)

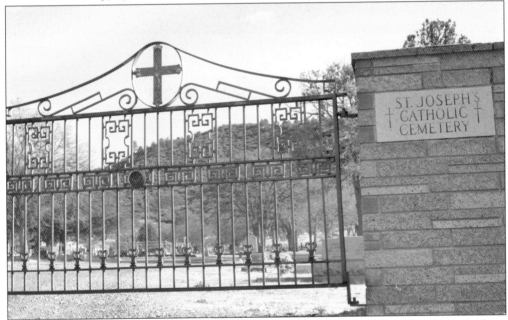

St. Joseph Catholic Cemetery stands on Butcher Hill on the west side of Yreka Creek overlooking the city. Early photographs of Miner Street show the original white clapboard Catholic church standing in front of the cemetery. The list of people buried in the cemetery contains many of the founders of the community. (Courtesy Karen Cleland Collection.)

The Yreka City Board of Trustees, according to a plaque posted at this site, created the Yreka Chinese Cemetery in August 1877. There are 52 known individuals interred here. The cemetery is marked with one stone, which is inscribed in Chinese characters: "The Graveyard of Our Past Friends, Erected in the Mid-Summer of the 26th Year of Emperor Kwong Shui." (Courtesy Yale East, copyright © 2006.)

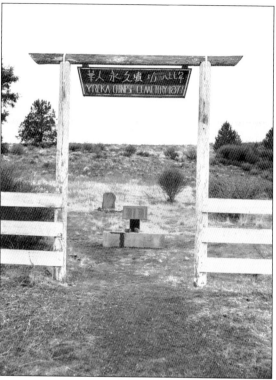

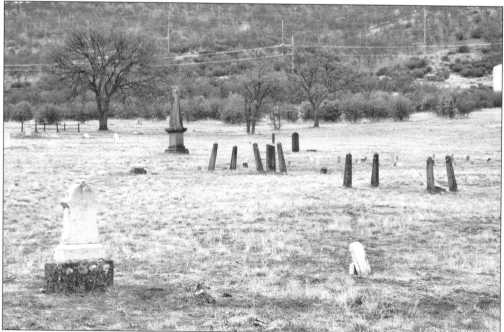

The Butcher Hill Cemetery, also referred to as Foothill Cemetery in some instances, is positioned without signage at the edge of town. The first known interment was in March 1855, and the last was in 1940. The name *Butcher Hill* refers to an area nearby, where a slaughterhouse had supplied meat to local markets in the early days of Yreka. (Courtesy Yale East, copyright © 2006.)

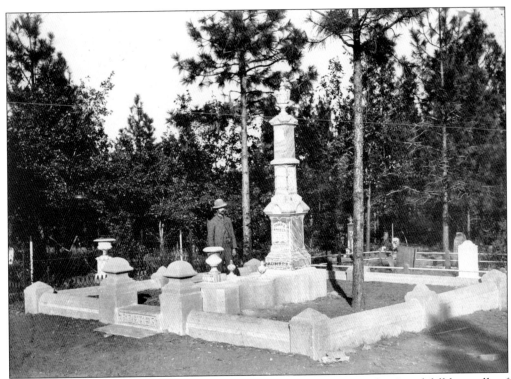

The John B. Rohrer plot is located in the Evergreen Cemetery in Yreka. Local folklore tells of Rohrer leaving a bottle with a note in December 1874 at the top of Goose Nest Mountain, at 8,289 feet. Rohrer was listed as the proprietor of the Franco-American Hotel in the Siskiyou County Directory just a year prior to his death. (Courtesy Siskiyou County Museum.)

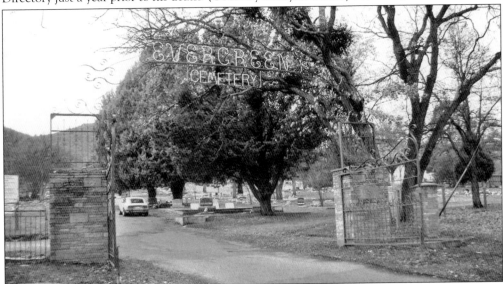

The entrance to the Yreka Evergreen Cemetery is located just beyond Evergreen and Meadowlark Lanes. There are graves that date back to early days of Yreka, as the cemetery first began under the leadership of the Masonic Order and the Odd Fellows in 1878. The first recorded person buried here was a child in 1878. (Courtesy Donald East, copyright © 2006.)

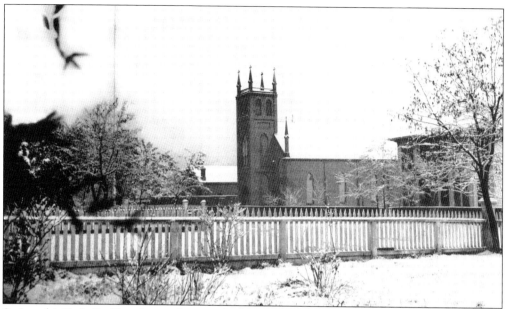

St. Joseph's Catholic Church was photographed on a cold winter day around 1885. The brick church was constructed after the devastating fire of 1871 and was located directly across from the Siskiyou County Courthouse. To the left is the building that served as the jail, surrounded by a sturdy brick fence. Both the church and courthouse stand today. (Courtesy Siskiyou County Museum.)

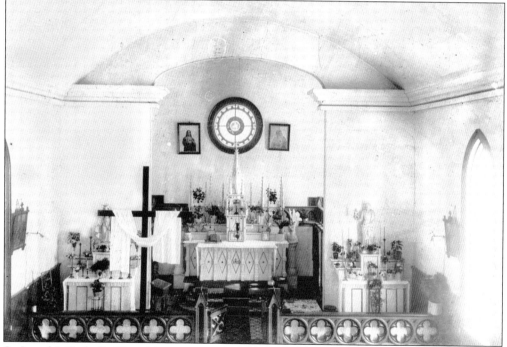

St. Joseph's Catholic Church's interior is seen around 1900. During this time, Fr. James O'Meara was serving the parish in Yreka. He served from 1899 to 1919. During this time, he often traveled to the Catholic church located in Hawkinsville to perform Mass for the worshipers there, as well as tending his duties in Yreka. (Courtesy Siskiyou County Museum.)

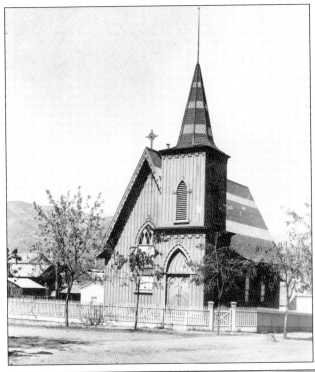

St. Mark's Episcopal Church first stood on the corner of Lane and Fourth Streets in 1880, and in January 1881, the church opened for services. According to records, the original cost of the building along with furnishings totaled $3,100. William Moses, a marine architect who carried a sea-faring theme in his work, designed the church. For years, church visitors marveled at the seven arches that supported the structure and recognized the similarities of sailing vessel construction. The interior shot of St. Mark's on Easter Sunday in 1890 gives an excellent view of how this originally appeared to the parishioners. (Both courtesy Siskiyou County Museum.)

Almost centered between the two trees is the house that served as St. Mark's Episcopal Rectory, built in 1889 and photographed around 1930. This was a mail-order house and one of the only known mail-order houses in Yreka. It was common practice for many years that a rectory was owned and kept by the church as a benefit to the pastor or priest. (Courtesy Siskiyou County Museum.)

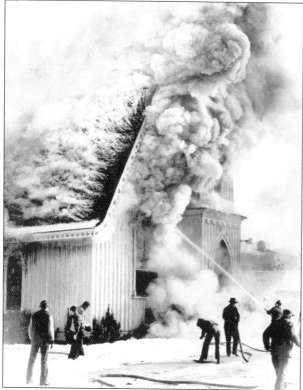

It happened in the 1960s during winter: fire broke out at St. Mark's Episcopal Church and flames and smoke appeared to doom this historic structure. The Yreka Fire Department fought and saved the building. The once-unusual roof structure had to be rebuilt, and the boat-like construction can no longer be seen. (Courtesy Siskiyou County Museum.)

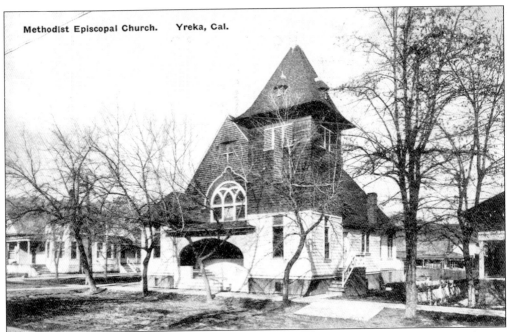

Methodist Episcopal Church. Yreka, Cal.

In 1898, the Methodist-Episcopal Church was built on the corner of South Oregon and Lane Streets. The former Union Church occupied this spot from 1854 until 1898, when the original building was dismantled. The Methodist-Episcopal Church was torn down in 1970, after a newer, larger church was built in 1964 in another part of the city. The Girdner Funeral Home currently occupies the site. (Courtesy Claudia East Collection.)

This lovely Victorian home was built in 1889 as the parsonage for the Methodist-Episcopal Church between South Oregon and Lane Streets. The home originally was located less than a block from the church while it served the parish. Today the Victorian church is gone, but the home still stands and proudly displays a small sign over the front door boasting of its origins. (Courtesy Marjorie Brooks Collection.)

Four

SCHOOLS
AND GOVERNMENT

GRAMMAR SCHOOL YREKA, CAL.

The first permanent schoolhouse in Yreka, built in 1856, is pictured here. The location of this building has been reported at various places through the years; however, close examination of maps and photographs show it was located near the current corner of Yreka and South Oregon Streets. This building was in use until approximately 1920, when the second elementary school was constructed nearby. (Courtesy Claudia East Collection.)

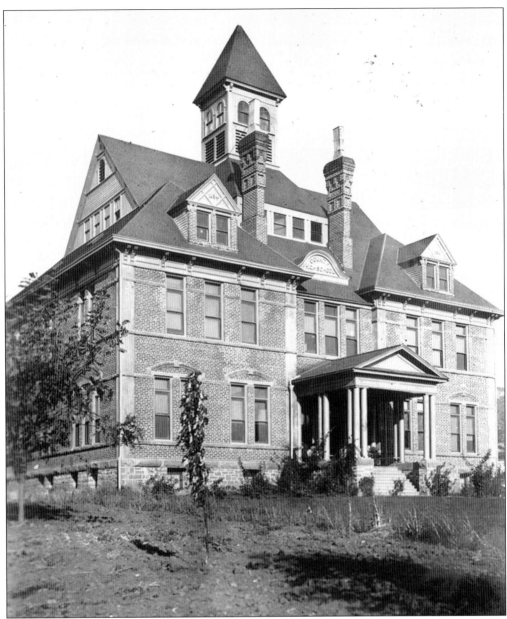

The Siskiyou County High School building cornerstone was laid on June 2, 1894. The school was built on the corner of North Oregon and Knapp Streets in Yreka for the cost of $17,725. It was later described in a publication prepared for the 1915 Panama-Pacific International Exposition held in San Francisco as an "excellent High School with a high standard of efficiency." October 3, 1916, turned tragic when this stately brick building suffered a massive fire and burned to the ground. It was reported that the fire began in the laboratory, where students had been working with chemicals earlier in the day. In 1918, a much larger and more modern stucco building was built on the site. The former site of these first two high school buildings in the county is now home to the Dr. Albert H. and Genevieve Newton Sports Park. A memorial plaque located at the corner of the sports park dedicates the history of these first two educational buildings. (Courtesy Claudia East Collection.)

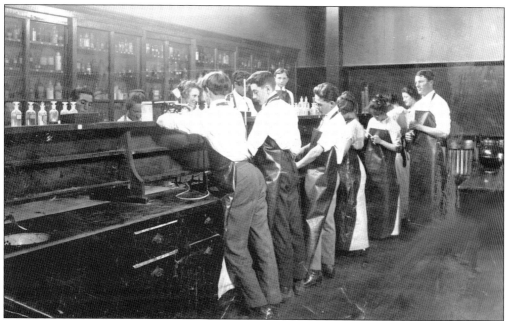

Students are seen here at work in the Siskiyou County High School's science laboratory around 1910. This is likely the laboratory where chemicals caused a fire that burned the school to the ground in 1916. Pictured from left to right are (first row): Henry Schaffer, Hank Mathews, unidentified, Myrtis (Skomo) Russell, Camill Albie, Mildred (Autenreith) Long, and teacher C. L. Hampton; (second row) Leona Scheld, unidentified, and Gerald Wetzel. (Courtesy Siskiyou County Museum.)

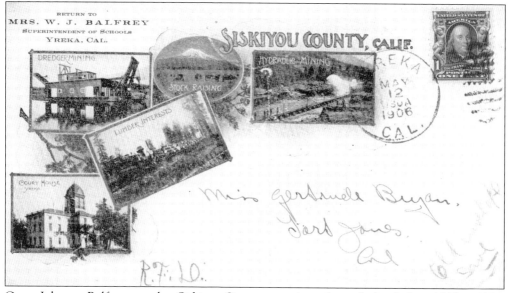

Grace Johnson Balfrey served as Siskiyou County superintendent of schools from 1902 to 1906. She mailed this envelope in her last year of service. Yreka serves as the seat of Siskiyou County, and the city and county promoted the assets of the area aggressively in the early part of the century, as is partially evidenced by the small images of industry on the envelope. (Courtesy Thelma Visger Collection.)

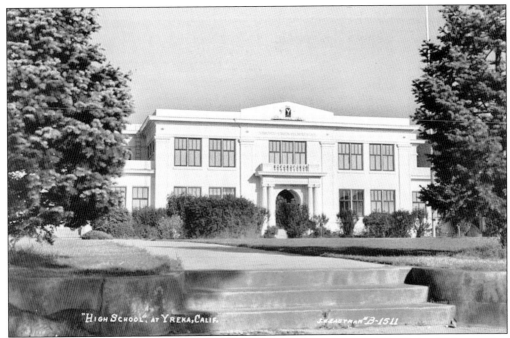

It was 1918 when this Siskiyou County High School building was erected in Yreka. This complex served the students full-time until 1958 and part-time until 1965. In April 1949, an article ran in the *Siskiyou Daily News* lauding the "cafeteria located within these walls" and described the hot meals served as "tasty victuals." Hot lunches were 35¢. (Courtesy UC Davis Special Collections.)

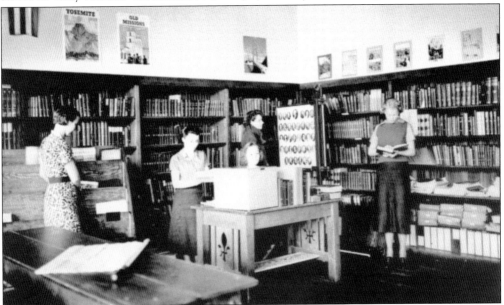

The Yreka High School library is pictured as it appeared in 1938. Among the collection the students might find some of the newest books of the year, such as *The Yearling* by Marjorie Kinnan Rawlings or *The Northwest Passage* by Kenneth Roberts. Perhaps they might even be searching for a copy of H. G. Wells's *War of the Worlds*, as the famous broadcast was made October 30, 1938. (Courtesy Siskiyou County Museum.)

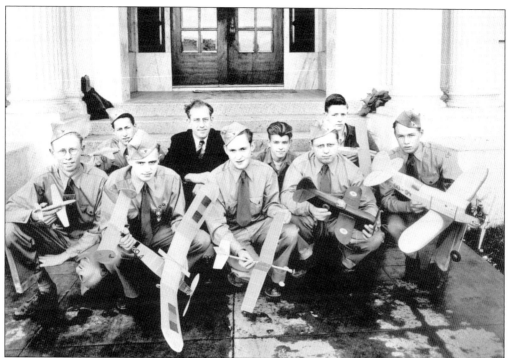

Yreka Air Scouts Squadron 91 displays model airplanes at Yreka High in 1944. The Air Scouts program, developed by the Boy Scouts of America, was established in 1942; however, the program ended in 1949. Members are, from left to right, (first row) Charles Rader, Walter Palmer, Jack Hurley, Alvin Kent, and Larry Reynolds; (second row) Kenneth Birdwell, Warren Tormey (advisor), Bob Turpin, and Wesley Johnston. (Courtesy Siskiyou County Museum.)

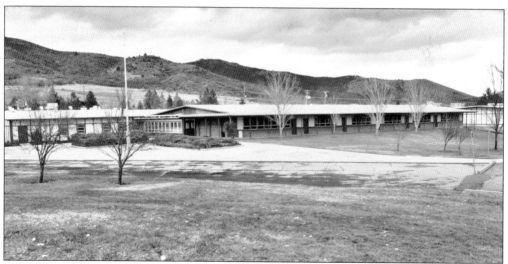

Pictured is the third high school building complex to serve the residents of Yreka. This building, located at 400 Preece Way, was first used during the 1959–1960 school year. It eventually replaced the plant that was built in 1918 near the current school gymnasium at the corner of Knapp and Oregon Streets. Yreka High School celebrated its centennial in 1994. (Courtesy Yale East, copyright © 2005.)

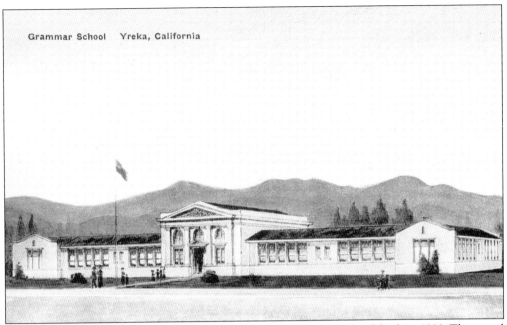

Grammar School Yreka, California

This is an architectural rendering of the second Yreka Elementary School, built in 1920. The actual constructed appearance of the center facade was slightly different than the proposed rendering. This school was situated at 725 Fourth Street, at the spot where Yreka City Hall currently stands. The entrance to the school was directly up Jefferson Street (currently named Dillon Way) at Fourth Street. (Courtesy Claudia East Collection.)

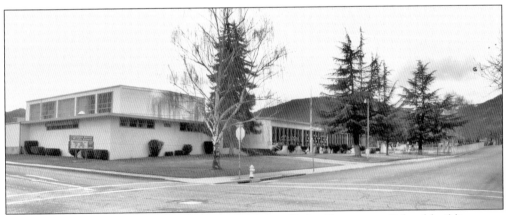

On April 20, 1949, the architect's plans for the new Yreka Elementary School building were displayed on the front page of the *Siskiyou Daily News*. This new school was designed for 16 classrooms and office facilities. That year, California Senate Bill 850 provided additional funds to help school districts provide additional classrooms, and Yreka's request was approved. (Courtesy Yale East, copyright © 2005.)

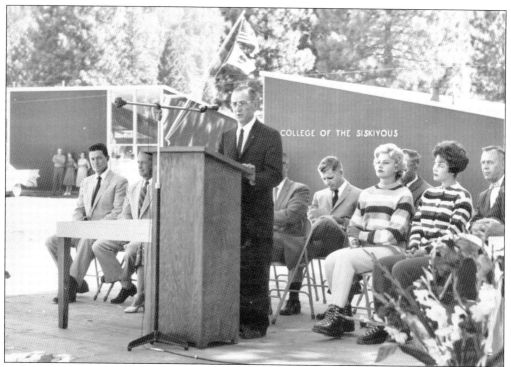

On September 6, 1959, the dedication of the new campus for the College of the Siskiyous occurred. Many communities within this new district eagerly sought to be the site chosen for this new campus. The School Planning Laboratory of Stanford University was employed by the college district to choose a campus site, and Weed was selected over Yreka for its more central location. (Courtesy the College of the Siskiyous Library.)

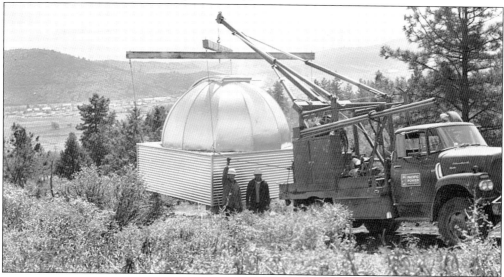

Chuck Fiock, along with a group of supporters, built this observatory in 1962 and placed it west of Yreka. About 1980, the telescope and building were donated to the College of the Siskiyous as an adjunct for coursework and the community, and it was moved near the Weed campus. In the early 1990s, the telescope was donated to a Fort Jones school. (Courtesy *Siskiyou Daily News*.)

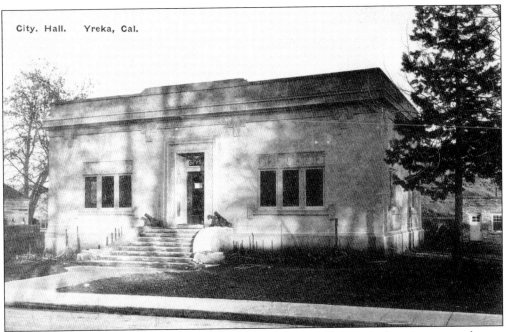

City. Hall. Yreka, Cal.

In 1913, the new Yreka City Hall was built at 120 North Main Street, the location currently part of the parking area for Miner's Inn. The police department shared this building with the city at the time. The current city hall was built on Fourth Street in 1972, and in 1976 the building above was razed. (Courtesy Claudia East Collection.)

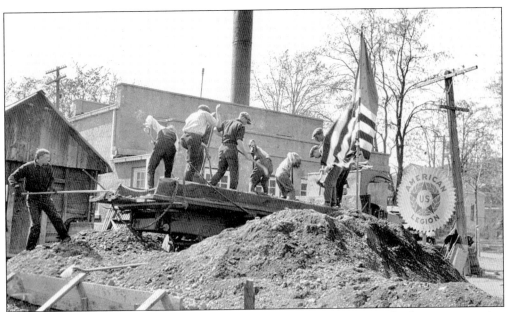

It is 1923, and the American Legion members are hard at work excavating for the new swimming tank, as it was called. This fondly remembered community pool was located directly behind the original city hall. The legion members donated considerable funds for the project as well as labor. It was planned for the pool to be given to the city. (Courtesy Claudia East Collection.)

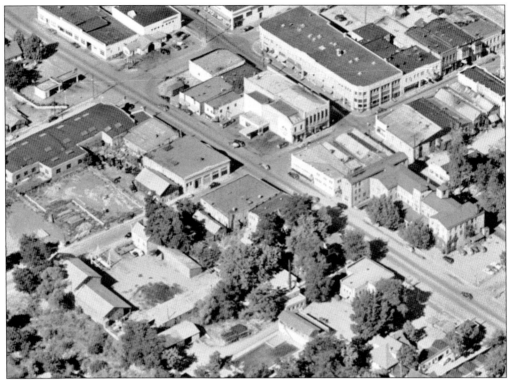

Above is a 1940s view of Yreka City Hall as it sat across the street from the Yreka Inn. Located right on Highway 99, the city hall was easily accessible and also housed the city police department. Looking at the image, enlarged from an Eastman aerial view of the town, one can see the community swimming pool that once sat behind city hall. (Courtesy UC Davis Special Collections.)

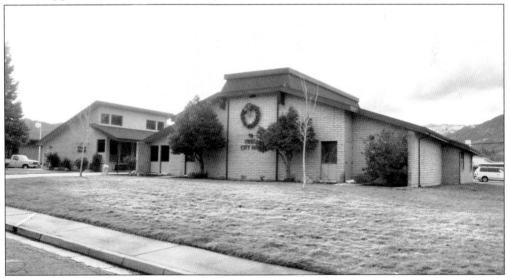

Yreka City Hall was built on this former site of the second Yreka Elementary School at the intersection of Dillon Way and Fourth Street in 1972. As one enters city hall, there are photographs of past city officers from the early 1900s and historical memorabilia on display. (Courtesy Yale East, copyright © 2005.)

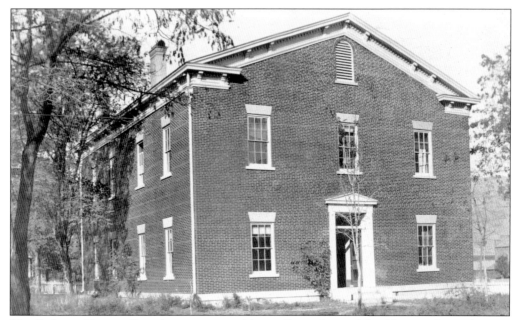

The Siskiyou County Courthouse remained basically unchanged for 40 years. It was here in November 1871 that Susan B. Anthony addressed a large Yreka audience on the topic of women's suffrage. The *Yreka Journal* of November 29, 1871, commented that it did not believe suffrage would extend any greater benefits to women but agreed they should receive proportionate pay equal with men according to the work. (Courtesy Marjorie Brooks Collection.)

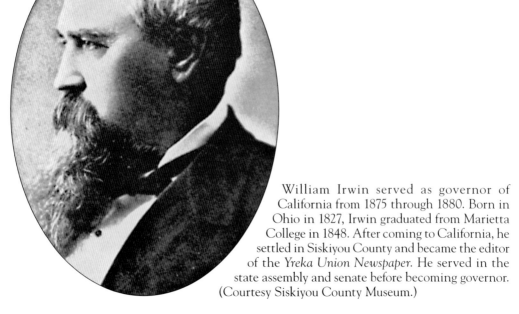

William Irwin served as governor of California from 1875 through 1880. Born in Ohio in 1827, Irwin graduated from Marietta College in 1848. After coming to California, he settled in Siskiyou County and became the editor of the *Yreka Union Newspaper*. He served in the state assembly and senate before becoming governor. (Courtesy Siskiyou County Museum.)

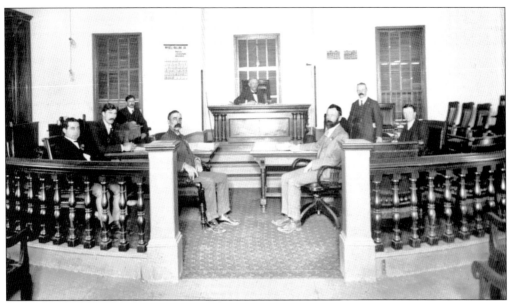

The main courtroom located within the interior of the Siskiyou County Courthouse is pictured in 1903. Seated from left to right are Charles Strother; C. J. Luttrell; W. J. Neilon; L. F. Coburn; Judge John S. Beard, on bench; J. F. Farraher; Frank Pollard; and court stenographer Frank Woodbury. This particular courtroom became the Yreka Justice Court about 1952. The courtroom is still in use today. (Courtesy Siskiyou County Museum.)

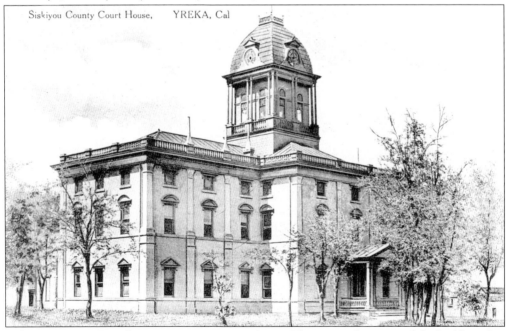

Siskiyou County Court House, YREKA, Cal

Siskiyou County Courthouse is seen in a c. 1905 view. The original portion of the building that was built in 1856–1857 can be seen in the center section. Wings on the north and south sides, along with the cupola, were added in 1896. The cupola was removed some time between 1915 and 1931, but the back view of the wings and center portion still appear much the same today. (Courtesy Claudia East Collection.)

The above photograph is a view of the side of the Siskiyou County Courthouse and Square, *c.* 1905. At the front left walks District Attorney Charles Luttrell, and to the right is Sheriff Charles Howard. Walking in the middle is likely Dora Chipps, a local woman convicted of murder when she was less than 20 years old who served her time at San Quentin. (Courtesy Siskiyou County Museum.)

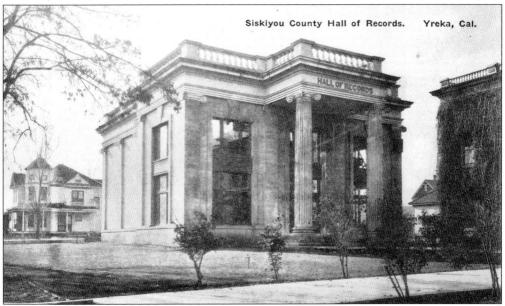

The Siskiyou County Hall of Records was built in 1910 and was viewed with great civic pride. The Hall of Records "addition," built in 1953, actually encased this building within its walls—the addition is usually thought of as the "new" courthouse building. At far left is the Rolland Orr House, which once sat at the corner of Butte and Fourth Streets. (Courtesy Claudia East Collection.)

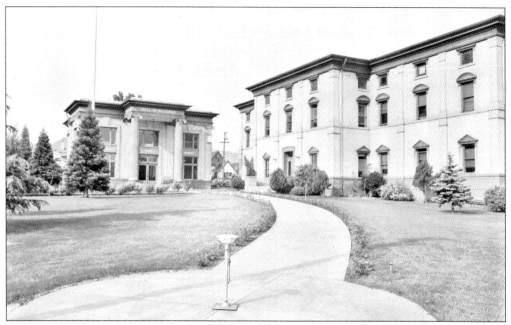

For many years, a giant stuffed mountain lion stood guard above the safe in the county treasurer's office. In July 1931, it was moved, and in the process the claw of the lion caught and triggered the burglar alarm that rang for several hours, creating a local stir. The courthouse and hall of records are seen in this photograph, taken in 1948. (Courtesy UC Davis Special Collections.)

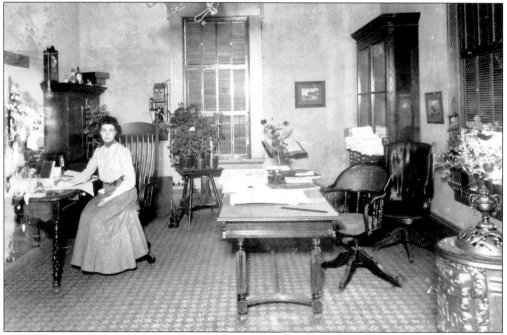

Grace Johnson is seated in the Siskiyou County Clerk's Office, located within the interior of the courthouse, in 1903. Even at this early date, electric lights were in use in the county offices as was telephone service. This room was likely in one of the newer north- or south-wing additions to the courthouse built in 1896. (Courtesy Siskiyou County Museum.)

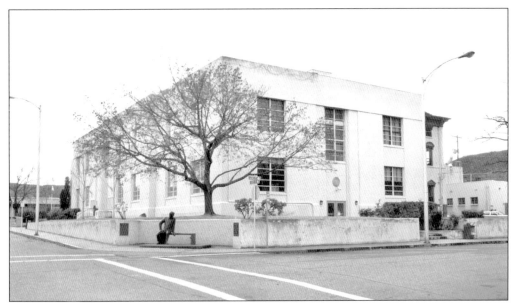

During 1953–1954, Siskiyou County had the above addition built on Courthouse Square; the bid for this new large addition was $286,213.42. Looking at the back right corner, a small portion of the north wing addition from 1896 can be viewed. The statue on the front corner is of Randolph Collier, former California state senator from Siskiyou County who served from 1938 to 1976. (Courtesy Yale East, copyright © 2005.)

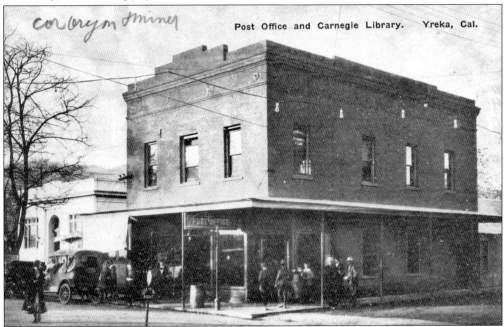

The two-story building shown above, located at 400 West Miner Street, served as the United States Post Office in Yreka for a number of years. The picture dates from some time between 1916 to 1920. Some time later, the post office moved into space available in the Warrens Building, once located on South Broadway Street. The post office was first established in Yreka on August 19, 1853. (Courtesy Claudia East Collection.)

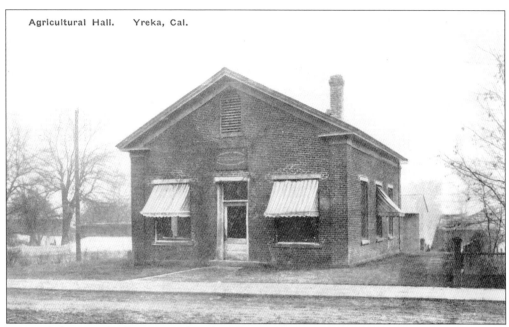

Agricultural Hall. Yreka, Cal.

Pictured above is the first Agricultural Hall of Yreka, California. This hall serviced the area until 1910, when a newer and significantly larger building was erected. Horticulture in Siskiyou County was a major industry even in the earliest years. The horticultural commissioner would instruct the new settlers concerning local growing practices and provide them with information on profitable methods of farming. (Courtesy Claudia East Collection.)

Yreka's second Agricultural Hall is estimated to have been built in 1910. It was located on the southeast corner of Center and Fourth Streets. This building was one of several showcased in the Siskiyou County Brochure, which was available at the 1915 Panama-Pacific International Exposition. Within these walls, the community could hold events, meetings, and fair and agricultural exhibits. The building was razed in the 1950s. (Courtesy Claudia East Collection.)

The first county hospital in Yreka was located near the site of the current Siskiyou County Museum. This hospital was built in 1870 and served until 1889. A painting of this building hangs in the hallway of the current county hospital, the Fairchild Medical Center. Beneath is a description of hospital life that includes a notation that the patients were responsible for the vegetable garden. (Courtesy Marjorie Brooks Collection.)

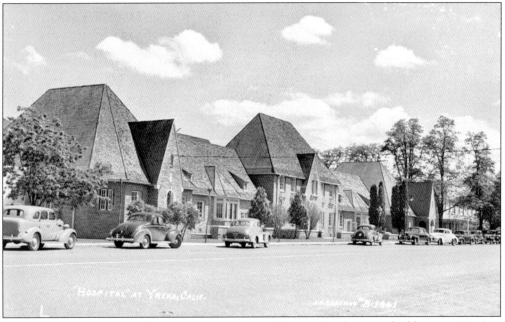

Originally constructed in 1926, the Siskiyou General Hospital is photographed here in 1941. Just a year later, on December 21, 1942, *Time* magazine wrote an article about a first that happened here. A small girl contracted the bubonic plague and was the first American case to be treated successfully with sulfadiazine by her Yreka physician, Albert Newton. (Courtesy UC Davis Special Collections.)

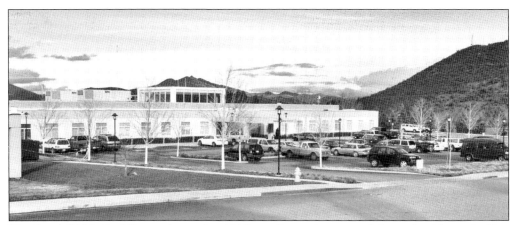

The Fairchild Medical Center, located at 444 Bruce Street, is a state-of-the-art healthcare facility. It was built in 1997 and currently serves the community and county. Its construction replaced the former Siskiyou General Hospital erected in 1921, which still stands on Main Street. The building complex now serves as county offices. (Courtesy Yale East, copyright © 2005.)

The archway to Yreka City Park was erected in 1921; the rocks chosen for the walls and pillars represent the various varieties of solid mineral deposits found in Siskiyou County. The park was often used during fair time as an outdoor exhibit hall before the fairground was built. Businesses downtown also featured various displays. (Courtesy Yale East, copyright © 2005.)

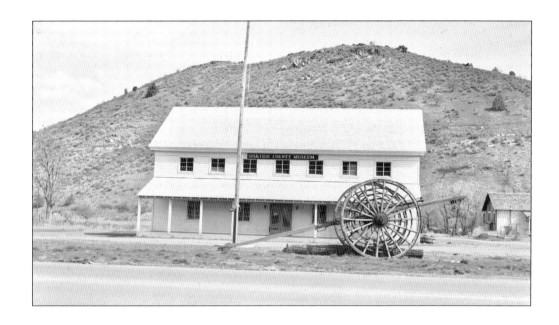

Building began in 1949, and the Siskiyou County Museum was completed in 1950. The building is located at 910 South Main Street near the city center. The Siskiyou County Museum was built to collect, preserve, disseminate, and interpret the history of the area for future knowledge and information. The museum was designed to resemble the Callahan Hotel, a historic structure located in Siskiyou County that was originally on the trail between Yreka and the goldfields of the Trinity Mountains. The town of Callahan developed around its historic hotel. (Above courtesy UC Davis Special Collections; below courtesy Karen Cleland Collection.)

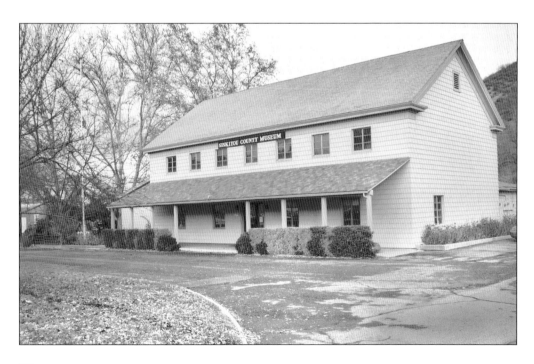

Modern-day Greenhorn Creek in Yreka is pictured above. Originally known as Race Creek, the name changed after three gamblers arrived in early Yreka and asked local miners where they could find good mining. As a joke they were sent out to Race Creek, in an area thought to contain nothing. Eventually, to everyone's extreme surprise, they found gold and struck it rich. (Courtesy Yale East, copyright © 2005.)

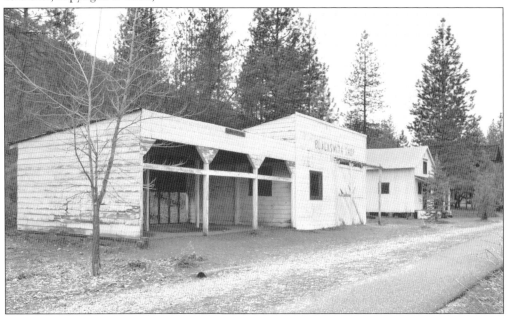

During the 1970s, Yreka underwent major changes in both modernization and preservation of its buildings. The town focused on preserving structures built prior to 1900 on Miner Street. With continuing effort, Greenhorn Park was developed in honor of the country's bicentennial, and a portion of the park has a historical display of vintage buildings as a small representation of how life once was. (Courtesy Yale East, copyright © 2005.)

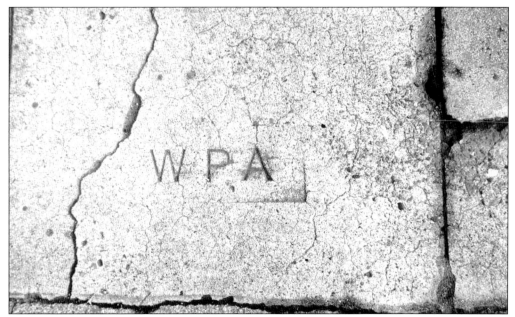

The Works Progress Administration (WPA) was created in May 1935 as a relief measure for semiskilled and unskilled citizens to combat unemployment during the Depression. For an average salary of $41.50 a month, WPA employees built bridges, roads, sidewalks, public buildings, public parks, and airports. This photograph is of a portion of the sidewalk along Miner Street that was a part of that project. (Courtesy Claudia East Collection.)

This is a Yreka advertising postcard from 1907–1915. Postcards during this time became a public addiction and hobby. They provided new ways to advertise, as people were using them as a fast way to keep in touch. Publishers printed millions of cards during this time, and most cards were printed in Germany, then the world leader in lithography. (Courtesy Claudia East Collection.)

Five

AREA INDUSTRY AND COMMUNITY EVENTS

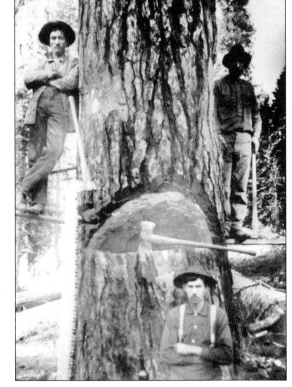

The loggers are standing on springboards, which allowed them to cut above the less valuable portion of the tree. The two-man crosscut saw was manufactured in many lengths and even came in one-man versions. They were replaced by the chainsaw in the 1950s, but many loggers still remember when men felled trees using only their muscle, ingenuity, and crosscut saws. (Courtesy Siskiyou County Museum.)

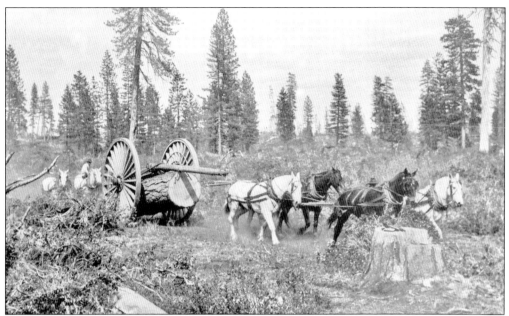

"High wheels" were invented in the summer of 1870 and by 1890 were used throughout the world. High wheels or "bigtracks" were one of the innovations responsible for large increases in logging productivity in the late 1800s and early 1900s. Because the logs were chained beneath the axle and dragged, it was relatively easy to keep them moving and required less horsepower. (Courtesy Siskiyou County Museum.)

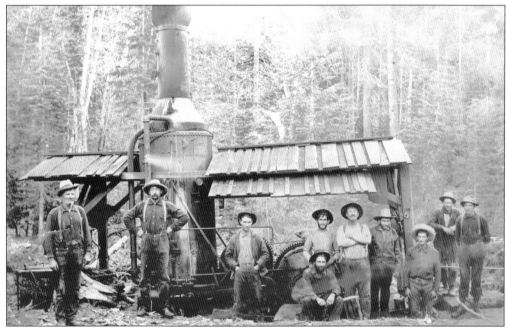

The "steam donkey" was developed in the late 1870s and became widely used in the late 1880s. It eventually replaced oxen and horse logging. The steam donkey anchored to a large tree and used wire rope to drag itself around the forest and to drag logs to a central area called a landing. It was another innovation that increased logging productivity. (Courtesy Siskiyou County Museum.)

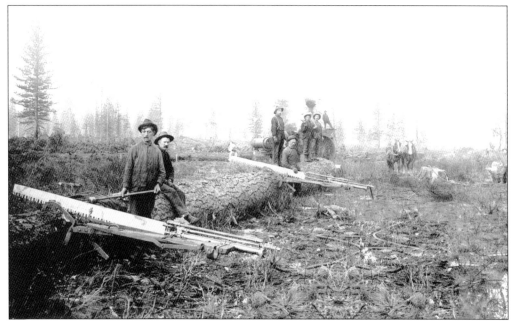

The steam donkey and later the steam tractor could be used to power the drag saw (steam-driven reciprocating saw), the predecessor of the chainsaw. The drag saw was used to cut logs into manageable lengths. Later versions of this were gasoline powered and were widely used in the field and in mills. (Courtesy Siskiyou County Museum.)

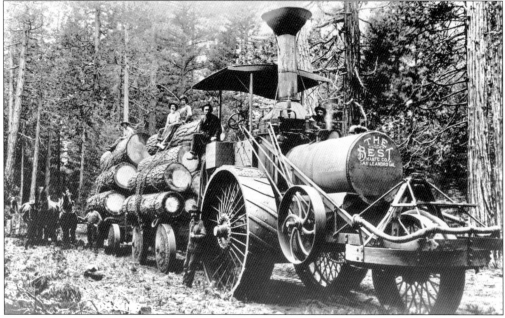

Daniel Best Steam Tractor Company of San Leandro, California, produced steam tractors between 1903 and 1907. The tractor could be used for either farming or logging. It was rated at 110 horsepower and replaced many teamsters and horses. The tractor could work all day and only needed to be fed when it was working. Farming and logging would never be the same. (Courtesy Siskiyou County Museum.)

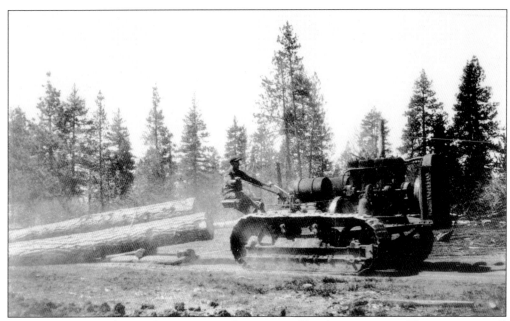

Steam tractors were heavy, dangerous, cumbersome, and hard to maneuver. They were not well suited to the steep terrain of Siskiyou County. This photograph shows the first model of the C. L. Best Tracklayer, which was built in by the C. L. Best Tractor Company in San Leandro, California, between 1916 and 1925. The photograph also shows Lovell "Leo" Brown, a driver at Hudson Mill, formerly Martin Dairy. (Courtesy Siskiyou County Museum.)

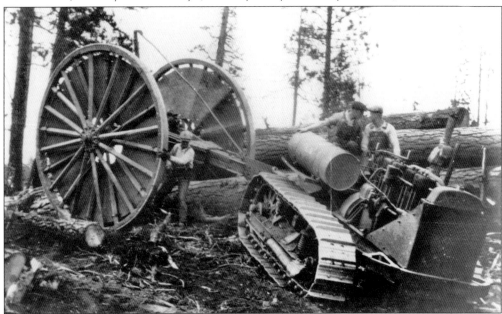

C. L. Best Tractor Company merged with Holt Manufacturing Company to form Caterpillar Tractor Company in 1925, and further innovations were made to continuous tracked vehicles. This photograph, dated 1928, shows an early Caterpillar tractor. It was well suited to the mountains and ran on gasoline. The high wheels were still used as before, but they would soon be replaced with a new innovation. (Courtesy Siskiyou County Museum.)

The back of this photograph reads: "1918 Bulldog Mack Truck. Owned by Len Carter, Driven by Arvell Carter. 20 feet less than 7,000 feet of sugar pine logs. One whole tree made three trips a day, 4-mile haul and 15% grade. Rugged country . . . up over 7,000 [feet] elevation. This old truck burned 70 gallons of gas daily, 40X8 high pressure tires, not a flat in 3 years." (Courtesy Siskiyou County Museum.)

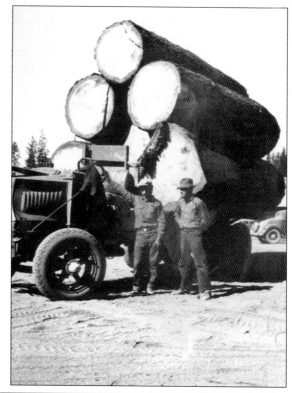

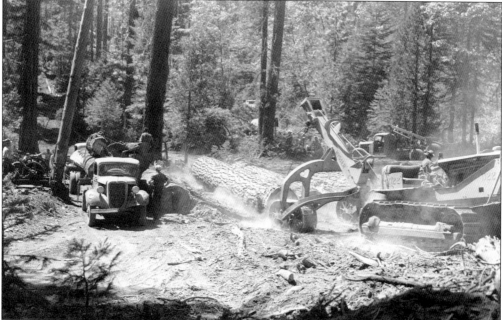

This photograph, taken in 1941, brings many innovations together. The Hyster wench took the place of the high wheels. The bulldozer and the logging trucks took the place of the horses. Only a few men and their machines could accomplish a great deal. Trucks allowed the logging of tracts of land far from rivers or mills. Men were able to live in Yreka and drive to the woods to work.

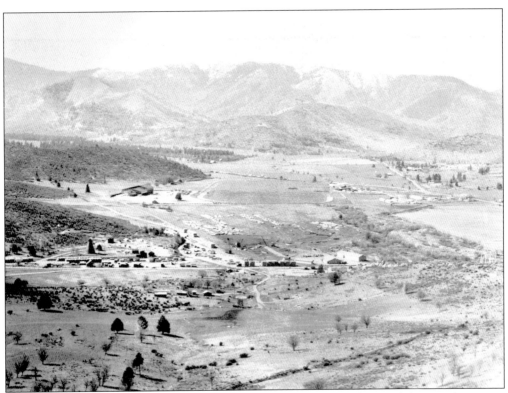

At one time, there were 13 lumber mills in the Yreka area. Truck after truck bearing logs came into town, and milled lumber left either by truck or railroad. There was the smell of wood smoke in the air surrounding the teepee burners. The photograph above, taken in the early 1940s, shows mills on the Oberlin and Sharps Road area. The fairgrounds in the upper center of the photograph are only apparent by the grandstand and racetrack. The image below shows the teepee burner and log ponds of the Pemberthy Mill. (Above courtesy Siskiyou County Museum; below courtesy Siskiyou Golden Fair.)

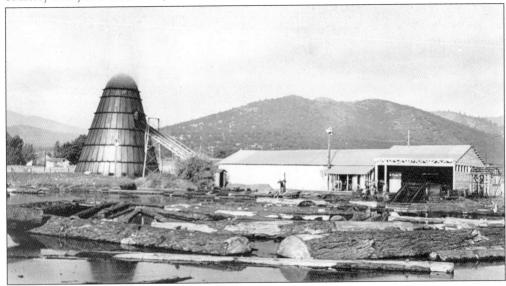

In 1909, the Doggett brothers were walking from Yreka to the Klamath River and stopped to have lunch on a hillside. While eating his lunch, Charles Doggett began idly digging with his hand and found gold. The Osgood Mine was discovered. The men shown at the Doggett discovery are, from left to right, Harry Doggett, Charles Doggett, Dell Fiddler, and Art Fiddler. (Courtesy Harvey Russell.)

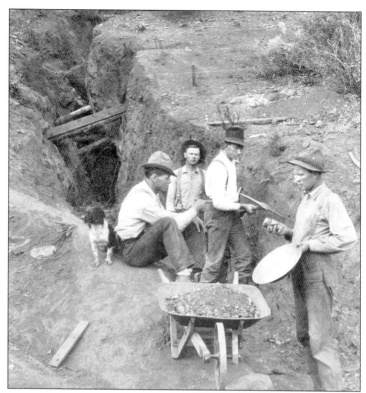

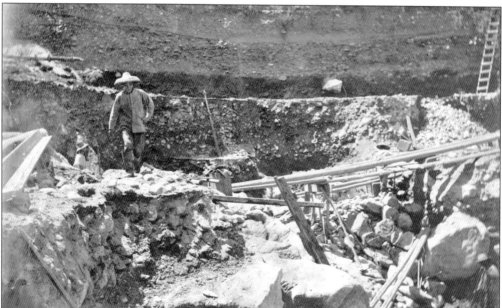

Chinese immigrants left their homes and families to come to booming California during the Gold Rush. They experienced intolerance and bigotry but persevered and became very good miners. Often their improvements and hard work made even abandoned mining claims quite profitable. This photograph shows a hydraulic mine named the Pine Grove Placer Mine. (Courtesy Siskiyou County Museum.)

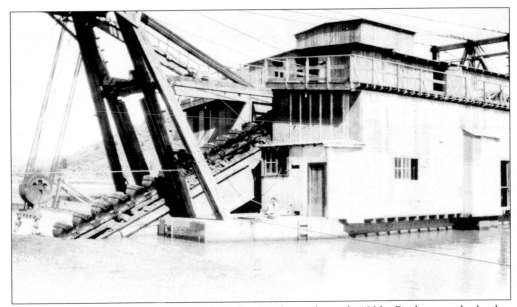

The gold dredge shown above operated north of Yreka in the early 1930s. Buckets on the bucket ladder picked up dirt, rocks, and ore and carried them to screening and sorting equipment inside the dredger, which separated the gold from the rest. The soil and rocks were discharged from the stern. The dredgers were very efficient and recovered gold valued at millions of dollars. (Courtesy Charlie Russell.)

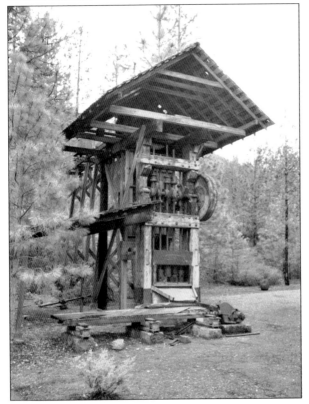

A relic from past gold-mining activity sits on display at Greenhorn Park in Yreka. This is a five-unit California stamp mill used to crush rock. A single head could process 1.5 tons of ore. The large wheel on the right was connected to a power source, and the cams would lift and release the weights, which fell by gravity to break down the ore. (Courtesy Yale East, copyright © 2005.)

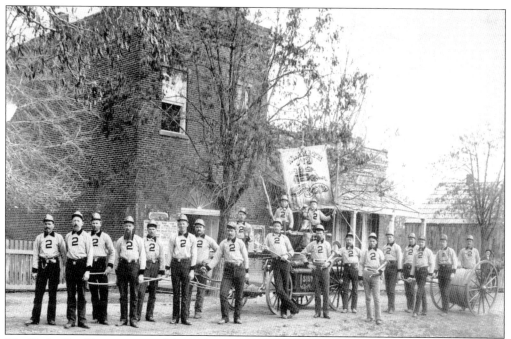

The Yreka Fire Department celebrated 150 years of service to the community in 2006. Klamath Engine Company No. 2, shown above, was organized in 1857. The banner they carry reads: "When Duty Calls, We Will Obey." The Hunneman hand-pumper (hand-tub) and hose cart required a large crew to operate but was very efficient and was used well into the 1920s. (Courtesy Siskiyou County Museum.)

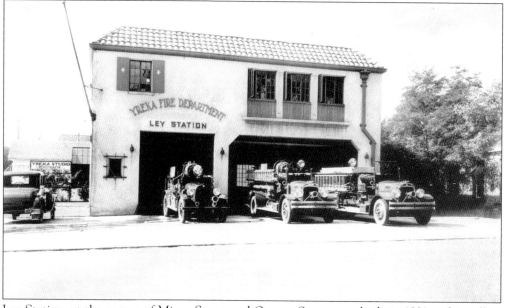

Ley Station, at the corner of Miner Street and Oregon Street, was built in 1931 and is still in use today. It was named for Maj. Horace Vincent Ley, former city attorney and fire chief. This photograph, taken in the mid-1930s, shows the well-equipped station with gear and trucks ready to meet the needs of Yreka. (Courtesy Siskiyou County Museum.)

Harvesting in the early days required plenty of horsepower and manpower. This photograph shows the Lee Farm. The driver of the hay wagons had to sit high above the horses so that he could see what lay ahead of the lead horses and to prevent hay from collapsing over him. (Courtesy Siskiyou County Museum.)

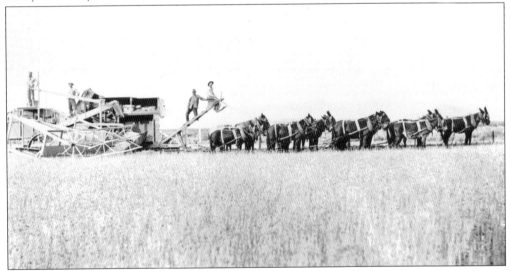

The horse- or mule-drawn combine took the place of the horse-drawn reapers and stationary threshers. It required teams of 16 or more horses or mules but still was more efficient and could cut and thresh over 100 acres a day. This photograph was taken on Willow Creek in the Shasta Valley. (Courtesy Siskiyou County Museum.)

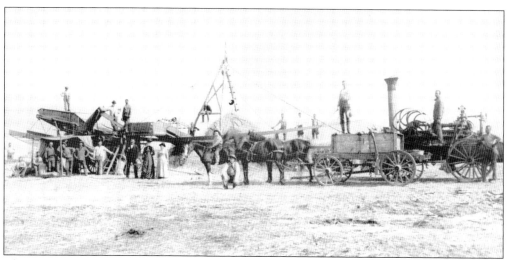

The early steam engines were hauled to the field by horses and only provided belt power for threshers. They were very expensive, heavy, and difficult to pull, but they provided steady power and did not tire. Soon they would become self-propelled but still needed horses to turn them. This photograph shows the transition period. (Courtesy Siskiyou County Museum.)

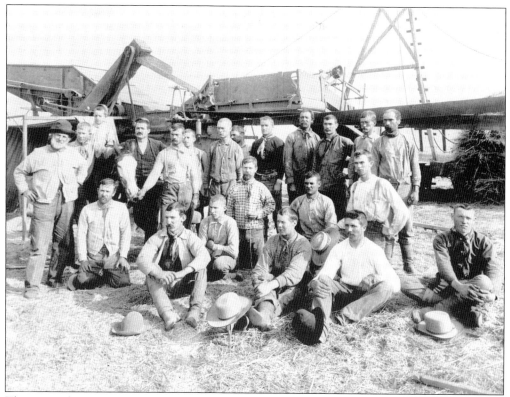

This 1890 photograph shows the Wise threshing crew at the Herzog Ranch northeast of Yreka. Nationally, in 1830 it took 250 to 300 labor hours to produce 100 bushels of wheat; in 1930, it took 15 to 20 labor hours to produce the same 100 bushels of wheat. (Courtesy Siskiyou County Museum.)

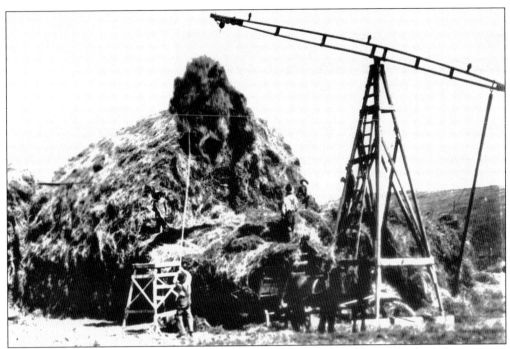

After the crop was cut and threshed, the hay still needed to be gathered into piles, loaded on wagons, hauled to a convenient location, and then stacked. The derrick was later used to load wagons with hay that was to be taken to animals for feed. (Courtesy Siskiyou County Museum.)

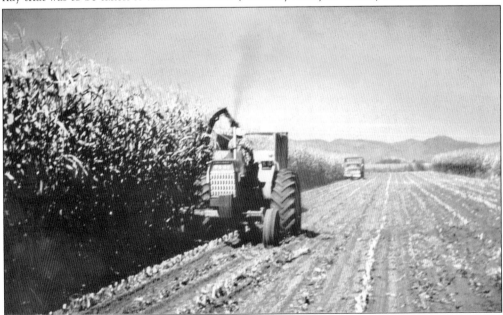

The farms in Siskiyou County are benefiting from the advances in agricultural machinery. One man, with a tractor, corn chopper, and silage trailer can accomplish as much as the large harvesting crews of yesterday. In the past, harvest was a time for neighbors and crews to work together and strengthen social bonds, but today machines make the harvest a more solitary pursuit. (Courtesy Siskiyou County Museum.)

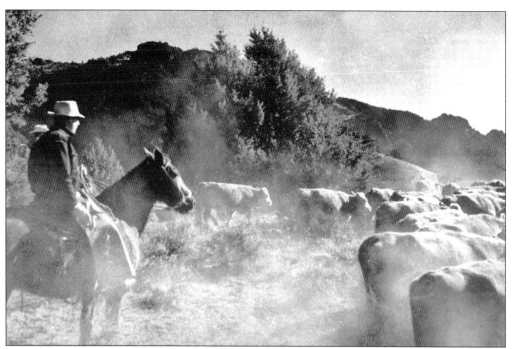

Early photographs and drawings of Yreka show ranches surrounding the town. In the 1850s and 1860s, it was difficult to get cattle to Yreka. They had to be driven over 100 miles through tough terrain and many were lost or died on the way. Even though Yreka was known as a gold-mining town, much of its economy was based on the cattle business and farming. Ranching and farming are still a strong component of the local economy and are the source of much of the character of Yreka and Siskiyou County today. (Both courtesy Siskiyou County Museum.)

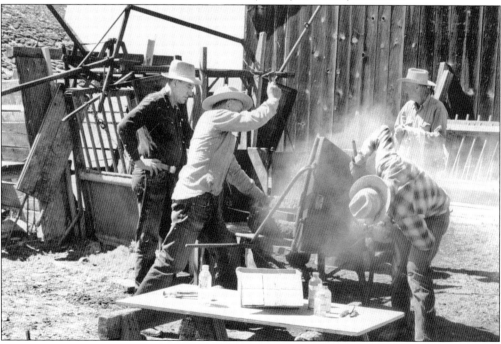

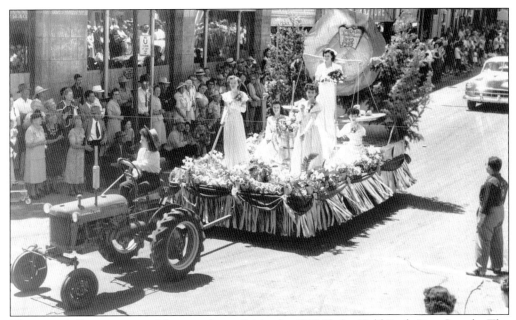

The queen's float was one of the most beautiful in the 1949 Yreka Gold Rush Days Parade. The gowns of the queen and her attendants were flown to Yreka from New York City and arrived just in time. The queen and her attendants are, from left to right (first row) Lois Stagg, unidentified (possibly Anne Patterson), and Bianca Pastega; (second row) Ilene Sutcliffe (queen) and Marjorie Burgess. (Courtesy Charlie Russell Collection.)

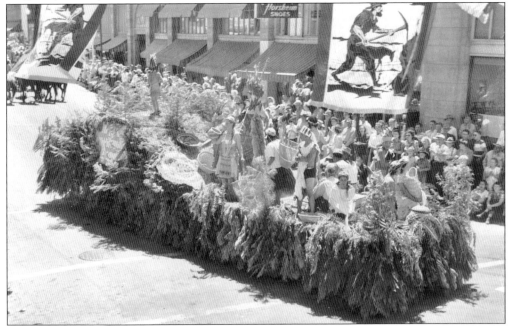

The judges of the 1949 Yreka Gold Rush Parade awarded a grand prize trophy to the community of Happy Camp for this float. The float, decorated with tree boughs and other natural materials, depicts the culture and life of the Karuk People of the Klamath. (Courtesy Charlie Russell Collection.)

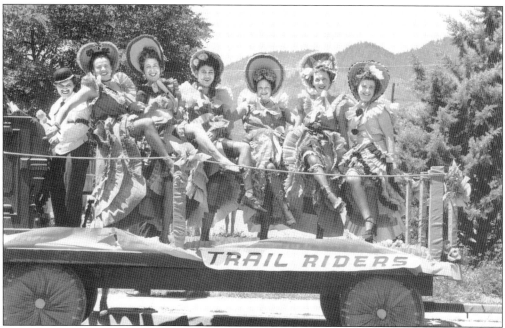

Yreka Gold Rush Days, held in 1949, was a spectacular three-day celebration. The parade sweepstake-winning Trail Riders entry included a saloon scene, singing cowboys, and the can-can dancers shown here. From left to right, Alice Newton, Mary James, Jo Kinney, unidentified, Naomi Payne, unidentified, and Amy Ling harkened back to dance-hall girls of Yreka's wild-west days of the 1850s. (Courtesy Charlie Russell Collection.)

The Siskiyou County Sheriff's Posse was formed for serious purposes, but its drill and parade team will be remembered for thrilling crowds with precision maneuvers and spectacular jumps over fiery barriers. The riders shown in this 1949 photograph are, from left to right, Roy Beckley (president), Dennis Malloy, Ed Marlahan, and Joe Lema. (Courtesy Siskiyou County Museum.)

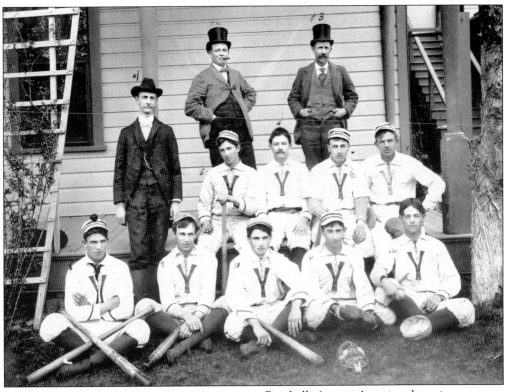

Baseball, America's national pastime, was one of Yreka's favorite pastimes too. Most of the towns in Siskiyou County had at least one team, and competition was fierce. Team members often traveled many miles to play a game. The caption under the above photograph, dated 1899, reads: "Yreka won from Edgewood, score 1 to 0, 'Home Run Kid', Al Conley won the game." The back of the photograph also reveals that the winning team was awarded $1,000. The team members are, from left to right, (first row) H. Roop, ? Bulis, Al Conly, Ray 'Skinny' Gregory (catcher), Gordon Jacobs (pitcher); (second row) Jim Beard, Frank Reilly, H. Wempe, Jim Bridges; (third row) H. F. Brown, Harry Patterson, Charles Herzog. The young men shown at left, Gordon Jacobs (pitcher) and Ray "Skinny" Gregory (catcher), were members of the Yreka baseball team in 1899. (Both courtesy Siskiyou County Museum.)

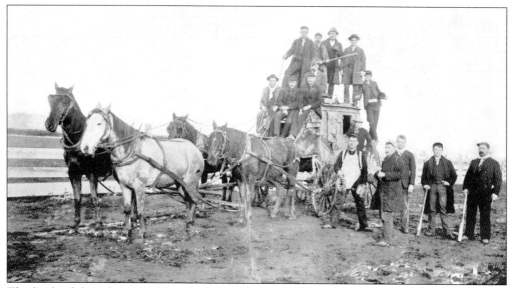

The back of this photograph reads: "Yreka Baseball Team rented Concord coach from Sam McNeal and team from Henry LeMay to go to a game in Klamathon." The photograph, taken about 1892, includes the stage driver and team members Henry LeMay, Julien Willis, Powell Willis, John Pashburg, Fred Dewey, Ed LeMay, Frank Herzog, Mort Hawkins, Jack Horn, and Dr. Irving Ward. (Courtesy Siskiyou County Museum.)

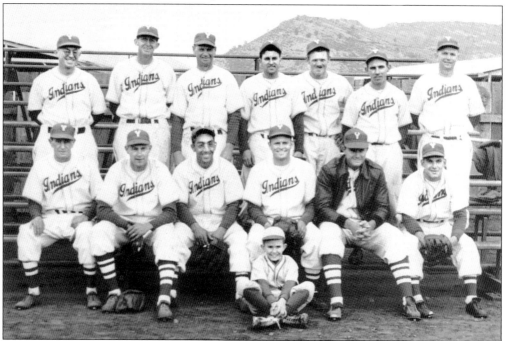

The Yreka Indians represented Yreka for many years. Games were not played during World War II, but play resumed after the veterans came home. The Northern California League covered a large area, and caravans of fans followed the team to cheer them on. The games were played on Sunday afternoons, and money dropped in a hat was used to pay for the team's uniforms, bats, and balls. (Courtesy Charlie Russell Collection.)

The Chinese New Year Celebration was enjoyed by everyone in Yreka. Chinese teams from many surrounding mining camps came to Yreka to celebrate and also to participate in the "fight." The teams marched to a central place and the fight began. A fuse would be placed in the neck of a large bamboo-wrapped jug. The jug was placed in the center of a circle and the fuse lit. The explosion would send the bottle high into the air. A mad scramble would be made to catch the bottle and carry it to the joss house. The man who first entered the joss house with the bottle in hand would win a trip to China to visit family and friends, and his team members would receive a large cash prize to share. This photograph shows the march following the fight. (Courtesy Siskiyou County Museum.)

The Yreka Brass Band poses in front of Turners Hall on Miner Street in 1900. The early Yreka band was organized to provide entertainment for Yreka and adjacent mining camps. The band provided many entertaining occasions by performing at celebrations, evening concerts, dances, and sports events, and was well supported by the residents of the town. (Courtesy Siskiyou County Museum.)

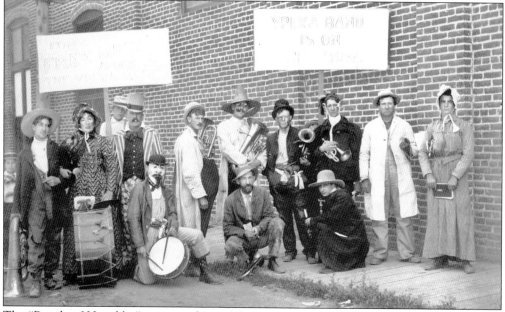

The "Parade of Horribles" was a traditional feature of Fourth of July parades. The Yreka band seems very good at being horrible. This photograph, taken July 4, 1907, shows, in no particular order, Floyd Collar, Lucian Guilbert, Henry Schock, Walter Pollock, John Walbridge, Bill Clute, Herman Schell, Harry LeMay, Jake Snooks, Henry LeMay, and Fred Meamber. (Courtesy Siskiyou County Museum.)

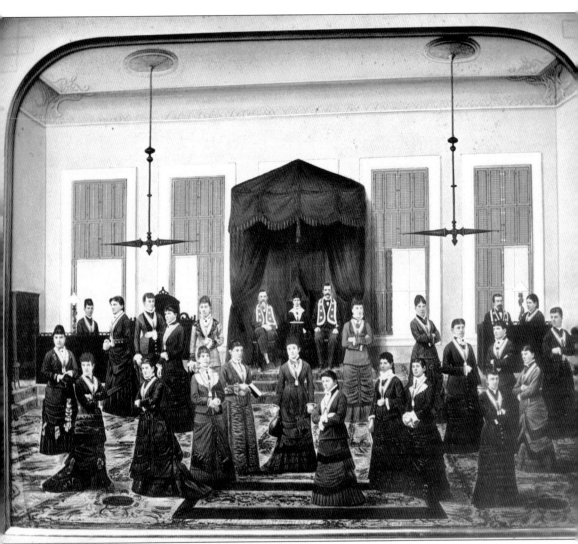

This large painting was presented to the Hope Rebekah Lodge of Yreka in 1882 by noted photographer Jacob Hanson, and graces the wall of the Odd Fellows Hall still. The Hope Rebekah Lodge began December 29, 1876, and has played an important role in the community for many years. The names listed on the back of this photograph of the painting are Robert Nixon, Mrs. Robert Nixon, A. E. Paine, Mrs. Schofield, Jacob Hansen, Mrs. Geo Fried, Mrs. Louise Moore (Fried), Minnie Hearn, Louise Schlagel (Fiock), Mrs. Hugo Miller, Dora Larison, Etta Wallace (Sleeper), Pearl Brown, Belle Jensen, Mrs. L. Swan, Laura Huseman, Sophie Winkler, Dalia Winkler, Julia Sleeper, Mrs. J. M. Walbridge, Mrs. C. Renner, Nettie Magoffey, Katie Peters, Sophie Lee (Fried), Belle Hearn (Martin), and Emma Schlagel. (Courtesy Siskiyou County Museum.)

The photograph above shows the detail of the interior of the Masonic Hall as it looked in 1898. The funeral of Dr. Sweitzer Harwood, shown below, was held in the Masonic Hall in 1893. Those Masons attending the funeral are, from left to right, (first row) Frank Hovey, Dr. Adwin Collar, S. F. Coburn, Allen Newton, George Butler, H. B. Gillis, Dr. ? Ream, Dr. Henry Robertson, H. Schroder, M. Sleeper, ? Bennett, Sam Pellet, and Dan Kennedy; (second row) John E. Harmon, Nick Young, Fred Wadsworth, William Hobbs, Austin Hawkins, Dr. Daniel Ream, Dave Ream, Mack Beem, Morris Renner, Bud Powers, ? Jacobs, Robert Tapscott, W. W. Powers, Bert Raynes, and Louis Nordhain. The current Masonic Hall was built in 1926–1927 at the intersection of Third and Miner Streets. Today the entire first floor is owned by Cooley and Pollard, Inc., a large local hardware store, and the Masonic Hall occupies the second floor of the building. (Above courtesy Wilbur Van Over; below courtesy Siskiyou County Museum.)

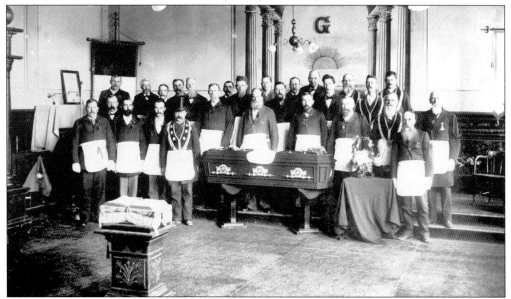

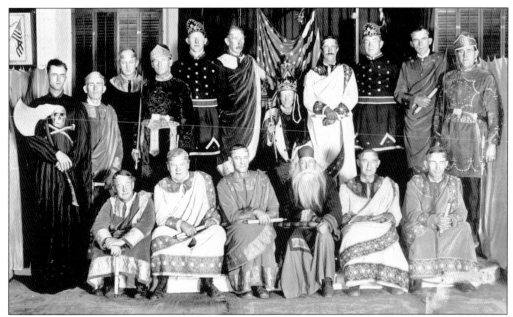

The Knights of Pythias, a fraternal organization formed to promote the principals of friendship, charity, and benevolence, was active in Yreka for many years. Seated from left to right are James Thomas, Hermon Ramp, Charles Grover, Uly Brown, M. Madelen, and M. Nunsmaker. The other men included in the photograph are, in no particular order, Mr. Cody, Bill Thomas, George Tebbe, Lawrence Schultz, Leo Toms, Albert Thomas, Myron Carrick, Si Clark, Joe Forrest, and H. C. Schultz. (Courtesy Siskiyou County Museum.)

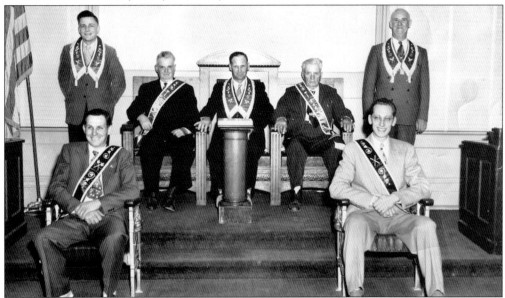

The Independent Order of the Odd Fellows of Yreka was organized in 1853. Its motto, "Friendship, Love, and Truth," supported its members during the early tumultuous days of Yreka's founding and supports its members still. The men shown are, from left to right, (first row) Walter Peters and Eli Klotz; (second row) David Oaks, Clarence Meek, Johnnie Hitchcock, Cal Winingham, and Bryon Russell. (Courtesy Ruth Seifert Collection.)

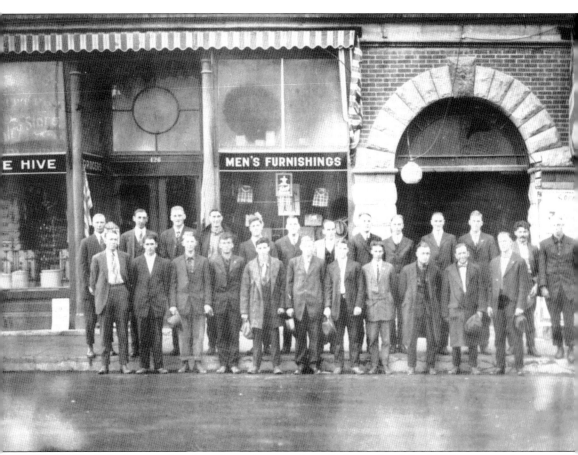

World War I draftees are lined up for a photograph in Yreka in the fall of 1917, prior to their departure. The soon-to-be soldiers were given a dinner at the Agricultural Hall, and each was presented with a basket of fruit as a departure gift. There were farewell speeches, information on the Red Cross, overtures by the Montague-Yreka Band, and a violin solo. When the reception was over a procession was formed headed by the Boy Scouts, followed by the band and the soldier boys as they marched to the train depot. They traveled from Yreka to Montague prior to their final exodus, and at Montague they were given a second reception. Each solider was given a packet of postcards and a book with the idea of establishing a circulating library among the draftees. One of the members was Ernest W. Robertson of Mount Dome, who had served in the United States Calvary at some time in the past and was given charge of the draftees owing to his previous experience. (Courtesy Siskiyou County Museum.)

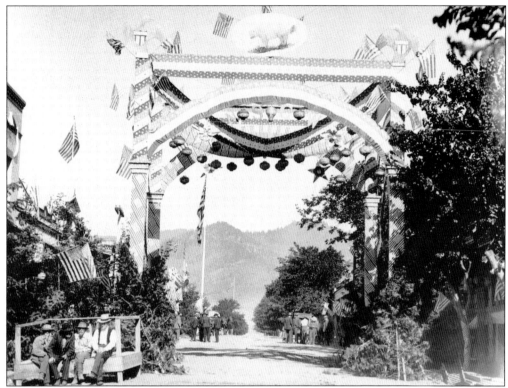

The Native Sons of the Golden West are known for their glorious arches topped with flags, eagles, and the California golden bear. This organization was created to memorialize the fortitude of the men and women of California during the days of the California Gold Rush. (Courtesy Siskiyou County Museum.)

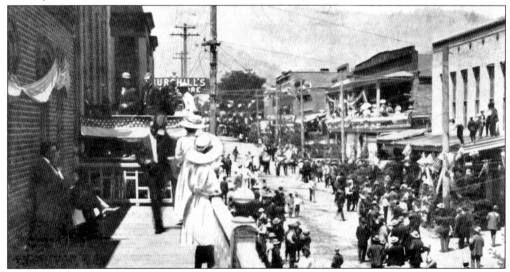

It was the Fourth of July Parade in Yreka, and the whole town was out to see or participate in the parade. The folks on the left are patrons of the Clarendon Hotel, with a balcony at their disposal. A new Masonic Lodge replaced the building on the right with the long tall windows in 1926. This card was mailed July 27, 1918. (Courtesy Claudia East Collection.)

The auto show displaying the new 1924 models was held as part of the annual Siskiyou County Fair in September 1923. The *Siskiyou News* reported that "the show has already grown to such proportions that it is looked forward to for months by motor enthusiasts and dealers alike." The 1923 show was planned to be the biggest the county had ever held. (Courtesy Siskiyou County Museum.)

This photograph taken in the Roaring Twenties shows Claude Russell seated behind the steering wheel of his Heinz 57 Hot Rod and his friend Abe ? seated on the running board. Claude built the car using any available parts. Other family pictures show that Claude drove this car many miles, but only in the summer. (Courtesy Harvey Russell Collection.)

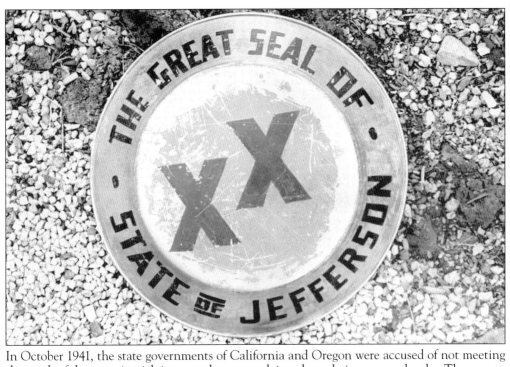

In October 1941, the state governments of California and Oregon were accused of not meeting the needs of the counties rich in natural resources lying along their common border. The county governments, businesses, timber workers, and miners of the region could see that improved roads and infrastructure were keys to economic growth and took steps to secede from Oregon and California and form the 49th state. The State of Jefferson was the winning name for the new state in a "Name the State Contest" held by the *Siskiyou Daily News*. As a symbolic gesture, the region seceded every Thursday, and armed men blocked the highway, stopped travelers, and gave them copies of the "Proclamation of Independence," describing the purpose and necessity of the movement. The Great Seal of the State of Jefferson is a gold pan with two Xs on the bottom. (Both courtesy Siskiyou County Museum.)

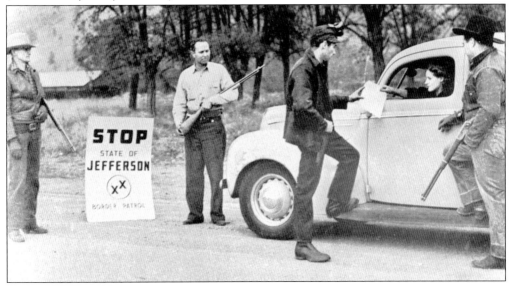

The "Provisional Territorial Assembly" met in Yreka on December 4, 1941. Judge John L. Childs of Crescent City, California, was appointed governor, and a rally was held at the Siskiyou County Courthouse. The plans for secession from California and Oregon captured the interest of the nation, and the rally and inauguration were covered by RKO, Pathe, and Movietone newsreel cameras. Plans to release the film to movie theaters across the nation were cut short by the attack on Pearl Harbor on December 7, 1941. On December 8, 1941, the State of Jefferson Territorial Committee issued a news release acknowledging the national emergency and proclaiming that the State of Jefferson would cease all activity. The above photograph shows the December 4, 1941, rally, and the photograph below shows, from left to right, (first row) Gordon Jacobs, Judge John L. Childs (appointed governor), and Sen. Randolph Collier; (back row) unidentified. (Both courtesy Siskiyou County Museum.)

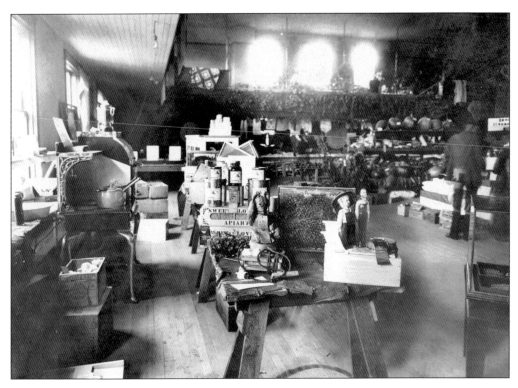

Siskiyou County's first agricultural fair was held October 5 and 6, 1859, in Fort Jones. Fairs were held there until 1867, when the event was transferred to Yreka. The early fairs were held in the downtown area. Exhibits were placed in empty stores and tents throughout the downtown area, and livestock was exhibited in livery stables. The above photograph was taken inside the Agricultural Hall at Fourth Street and Center Street. In 1925, land was purchased for a permanent fairground, and on September 18, 1928, the new fairgrounds opened and the fair ran for three days. The fair was not held during the Great Depression but reopened in 1938. The photograph below shows the midway about 1938. (Above courtesy Siskiyou County Museum; below Siskiyou Golden Fair.)

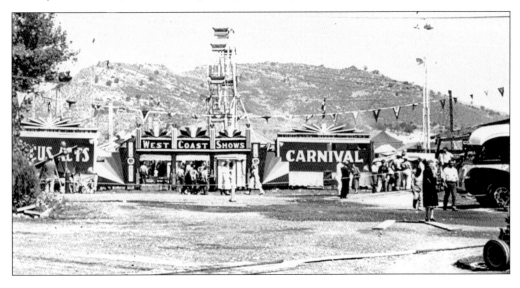

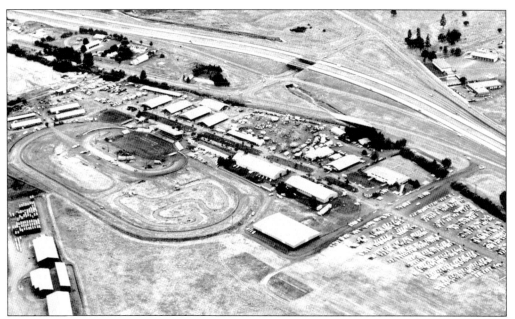

This aerial photograph shows the Siskiyou Golden Fair Grounds about 1970. Today the fair continues to have livestock, home arts, fine arts, and floral and horticultural competitions as well as the rodeo, a destruction derby, and a talent show. In 2006, the fair had more than 50,000 visitors and over 4,500 exhibits. The fair provides a wonderful opportunity to celebrate all that Siskiyou County has to offer. (Courtesy Siskiyou County Museum.)

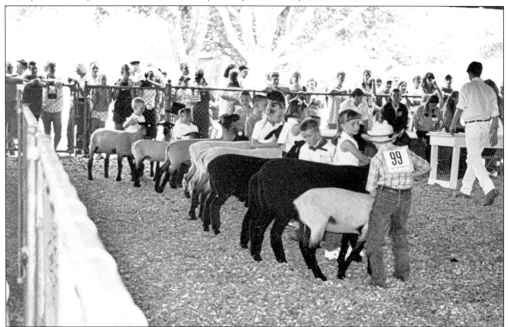

The junior livestock program is one of the most important activities at the fair. Competition encourages youngsters to do their best to raise and care for animals. They learn the value of preparation and elements of showmanship as well as basic economics. The youngsters take pride in what they accomplish and have a good time too. (Courtesy Siskiyou Golden Fair.)

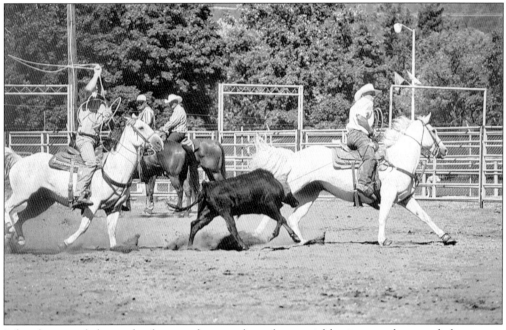

It has been said that rodeo began when cowboys from neighboring ranches needed a way to settle a dispute about who was best at performing everyday ranching tasks. The dispute seems never to have been settled, because rodeo is still a part of every fair and is always a crowd pleaser. (Courtesy Siskiyou Golden Fair.)

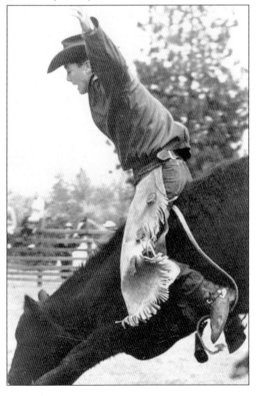

Junior rodeo competition can begin with five-year-old buckaroos clinging to barreling sheep. Soon the youngsters are roping, wrestling, and riding horses and bulls. It is a sport that can be continued for years. Some high schools have rodeo programs, and many colleges have a rodeo team. (Courtesy *Siskiyou Daily News.*)

County fairs form a link between urban and rural portions of the population, and the carnival is a place everyone enjoys. The background of music, excited chatter, and a few screams add to the excitement everyone feels when they enter the carnival. Fair competitors can squeeze in a few rides between chores, and the visitors will recount carnival-ride stories long after the fair closes. (Courtesy Siskiyou Golden Fair.)

This walk down the road between the mall greens at the fairgrounds, a short distance before the animal exhibit buildings, was photographed around 1965. Notice that the trees on the greens are newly planted; today they are full grown and provide welcome shade during the summer fair for the more than 50,000 patrons that attend the fair each year. (Courtesy Siskiyou Golden Fair.)

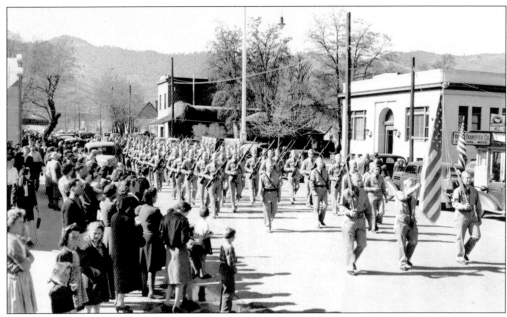

On March 7, 1942, Company M, 10th Regiment of the California State Guard performs its first out-of-doors drill exercise on Miner Street in Yreka. Company M was mustered into the state guard a few days after Pearl Harbor and had a strength of 95 men on this date. This company was to guard military objectives in Siskiyou County and form resistance against any invasion attempt. (Courtesy Siskiyou County Museum.)

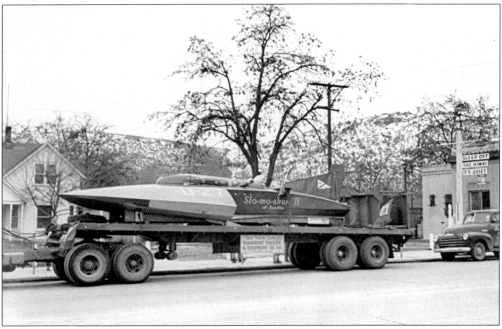

The *Slo-mo-shun IV* of Seattle was big news in 1950. It was the first prop-riding three-point hydroplane boat to run successfully in the unlimited classification for racing for the year. This celebrity came through Yreka while in transit and was photographed on Main Street, Business U.S. 99, parked close to the original Yreka City Hall. (Courtesy *Siskiyou Daily News*.)

Pres. Franklin D. Roosevelt, America's most famous polio victim, founded the March of Dimes. There were national campaigns to fund research, and at right is one of Yreka's efforts during the 1950s. It is difficult to explain the terror polio created—parents lived in constant fear their children would be stricken—as science did not know how it was contracted. (Courtesy *Siskiyou Daily News*.)

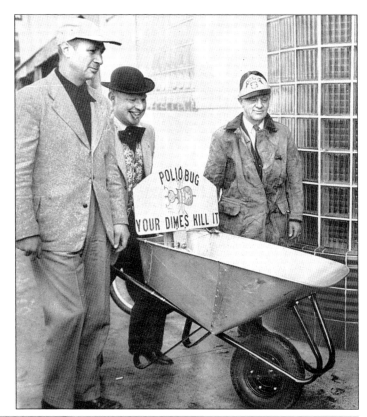

The Genealogical Society of Siskiyou County is an active group of individuals eagerly seeking out stories, information, and lineage about their ancestors. They meet regularly at the genealogical center shown above. The society frequently sponsors activities such as introductory classes and assistance to visitors seeking genealogical information. The center is adjacent to the Siskiyou County Museum at 912 South Main Street in Yreka. (Courtesy Donald East, copyright © 2007.)

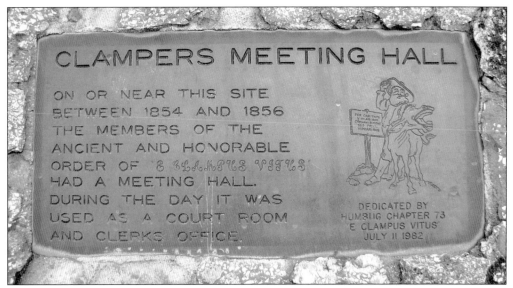

E Clampus Vitus is a fraternal organization dedicated to the preservation of the history of California focusing on gold-mining regions. Yreka has an active group assisting in the sponsoring of historical events, plaques, and sites. The marker above is dedication to a former saloon and rooming house that once served as the county courtroom and clerk's office by day. (Courtesy Donald East, copyright © 2007.)

The photograph above, c. 1950, was sent from a soldier whose identity is currently unknown while on maneuvers at Mount Fuji. He is reading a paper from home, the *Yreka Journal*. He mentions on the back to notice his mess gear hanging in his tent. The South Pacific nation of Fiji was a British colony for nearly a century before gaining its independence. (Courtesy *Siskiyou Daily News*.)

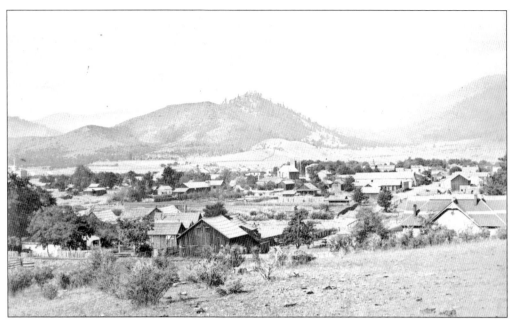

A rare view of Yreka's past is seen here with a photograph, *c.* 1895, taken from the east looking west at the government center. The original courthouse configuration is barely visible within the trees; however, the spires of the Catholic church are evident. The roadway visible on the right going toward the mountains is Center Street. (Courtesy Marjorie Brooks Collection.)

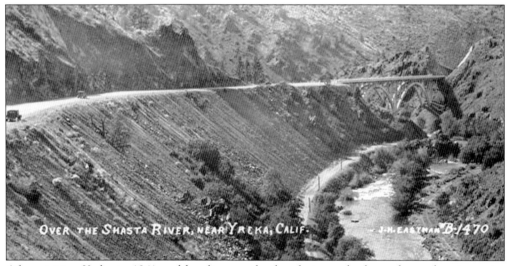

OVER THE SHASTA RIVER, NEAR YREKA, CALIF. J.H.EASTMAN B-1470

After visiting Yreka in 1941 and heading north, the photograph above shows the view prior to crossing the Shasta River on the new Highway 99. The bridges were important icons of community pride and often had markers to read about the construction; they frequently had walkways or sidewalks for people to get out and look at the view from the bridge. (Courtesy UC Davis Special Collections.)

ACROSS AMERICA, PEOPLE ARE DISCOVERING
SOMETHING WONDERFUL. THEIR HERITAGE.

Arcadia Publishing is the leading local history publisher in the United States. With more than 3,000 titles in print and hundreds of new titles released every year, Arcadia has extensive specialized experience chronicling the history of communities and celebrating America's hidden stories, bringing to life the people, places, and events from the past. To discover the history of other communities across the nation, please visit:

www.arcadiapublishing.com

Customized search tools allow you to find regional history books about the town where you grew up, the cities where your friends and family live, the town where your parents met, or even that retirement spot you've been dreaming about.